Antoni Gaudí

Grange BOOKS

Page 4:
Casa Vicens,
View of façade from Calle de Carolines

Baseline Co Ltd
19-25 Nguyen Hue
Bitexco Building, 11th floor
District 1, Ho Chi Minh-City
Vietnam

Casa Milà, La Pedrera (Barcelona). Thankfulness to Fundació
Caixa Catalunya

Published in 2005 by Grange Books
an imprint of Grange Books Plc
The Grange Kingsnorth Industrial Estate
Hoo, nr Rochester, Kent ME3 9ND
www.grangebooks.co.uk

ISBN 1-84013-773-8

Printed in China

"Ornamentation plays an essential part, in that it gives character, but nevertheless it is no more than meter and rhyme in poetry. A concept can be expressed in many ways, but it becomes obscure and pedantic when one wishes to introduce — those pedantic accessories which undermine the clear meaning of thought."

— Antoni Gaudí (Diary extract c. 1876-1879)

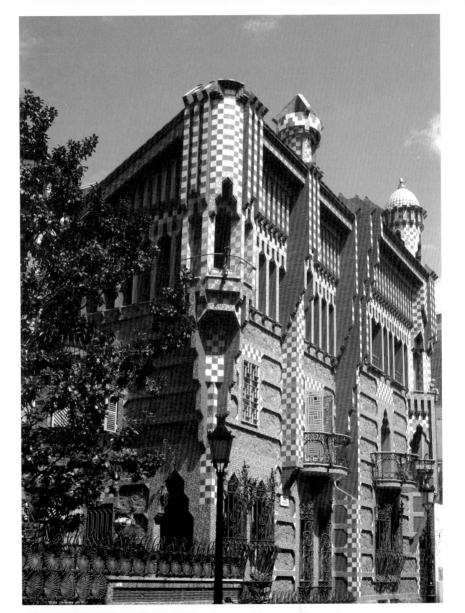

Biography

1852: Gaudí is born on 25 July, in the town of Reus.

1863: Gaudí starts his school education at the Convent of St Francis, Reus.

1868: Gaudí moves to Barcelona to complete his final year of secondary education at the Instituto Jaume Baulmes.

1869: Gaudí enrols in the Faculty of Science at the University of Barcelona.

1873: Gaudí enrols in the School of Architecture.

1875: Gaudí is called up for military service.

1876: The death of his elder brother Francesc and his mother Antonia.

1878: Gaudí qualifies as an architect.

1879: Gaudí joins the *excursionistas*. His sister Rosa dies.

1883: Gaudí starts work on the Sagrada Familia, the following year he is officially named architect of the project. Begins work on Casa Vicens and designs El Capricho.

1884: Gaudí begins building Las Corts de Sarría, on Güell estate.

1886: Work begins on the Güell Palace.

1888: Universal exhibition in Barcelona, including exhibit designed by Gaudí. Gaudí begins constructing the Colegio Teresiano. He begins work on the Episcopal Palace in Astorga and the Casa Botines in León; projects which continue until 1891.

1891: Gaudí travels to Tangiers and prepares designs for a Franciscan Mission.

1894: Gaudí subjects himself to strict Lenten fast and is bedridden.

1895: Gaudí collaborates on the Bodegas Güell with Francesc Berenguer.

1898: Gaudí begins the Casa Calvet. He develops model for the Crypt at the Colonía Güell.

1899: Gaudí receives award for municipal council for Casa Calvet.

1900: Work begins on the Park Güell

1903: Restoration of Mallora Cathedral begins.

1905: Gaudí, his father and niece move to a house in the Park Güell.

1906: Gaudí's father, Francesc, dies.

1910: Gaudí's first exhibition abroad, at the Grand Palais in Paris.

1911: Gaudí contracts brucellosis.

1912: Gaudí's niece, Rosa Egea i Gaudí, dies.

1925: The first of the Apostle Towers for the Sagrada Familia is completed.

1926: Gaudí is knocked down by a tram on 7 June and dies three days later on 10 June.

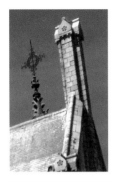

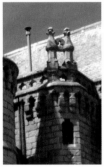

The life of Antoni Gaudí (1852-1926) is best told and analysed through a focused study of his works. The buildings, plans and designs testify to Gaudí's character, interests and remarkable creativity in a way that research into his childhood, his daily routines and working habits can illuminate only dimly. In addition to this, Gaudí was not an academic thinker keen to preserve his thoughts and ideas for posterity through either teaching or writing. He worked in the sphere of practical, rather than theoretical work.

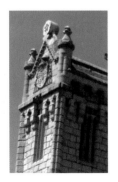

Episcopal Palace of Astorga

General view

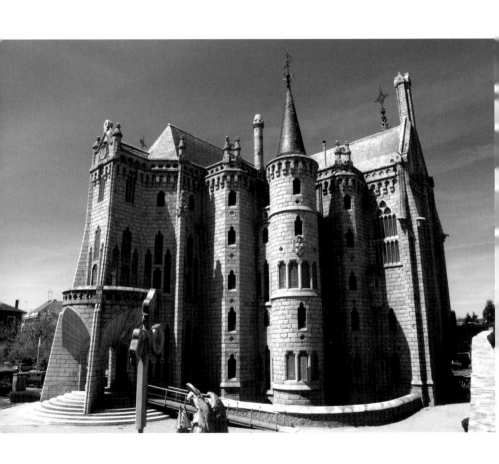

Were this not enough to challenge attempts to gauge the mind of this innovative architect the violence of Spain's Civil War resulted in the destruction of a large part of the Gaudí archive, and this has denied a deeper understanding of Gaudí the man, his character and thoughts. On 29th July in the first year of the Spanish Civil war the Sagrada Familia was broken into, and documents, designs and architectural models stored in the crypt were destroyed. The absence of documentation limits the possibility of a searching biographical study, and it has encouraged rather more speculative interpretations of the architect. Today Gaudí has gained an almost mythic status in the same way that his buildings have become iconic.

Episcopal Palace of Astorga

Entrance porch detail

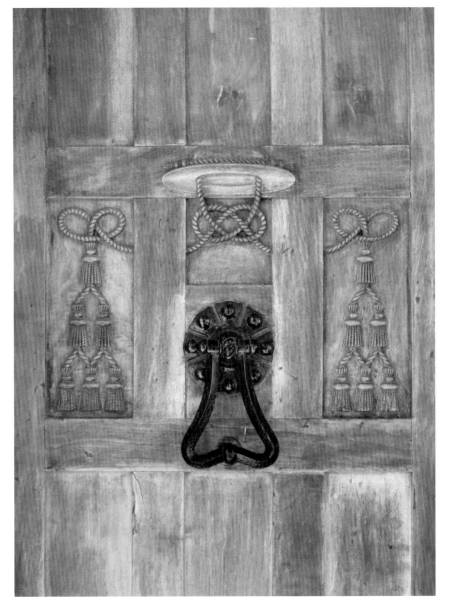

11

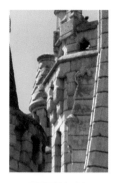

While his work continues to attract the 'devotions' of many thousands of tourists, his life inspires a range of responses. Besides the academic scholarship of Joan Bassegoda i Nonnell, for example, or the recent biographical study of Gijs Van Hensenberg, the life of Gaudí has prompted hagiographies and more imaginative reflections. In a different vein Barcelona's acclaimed opera house, el Liceu, premiered the opera *Antoni Gaudí* by Joan Guinjoan in 2004 and this process of cultural celebration has taken on a metaphysical dimension with the campaign by the Associació Pro Beataifició d'Antoni Gaudí to canonise him.

Episcopal Palace of Astorga

View of entrance

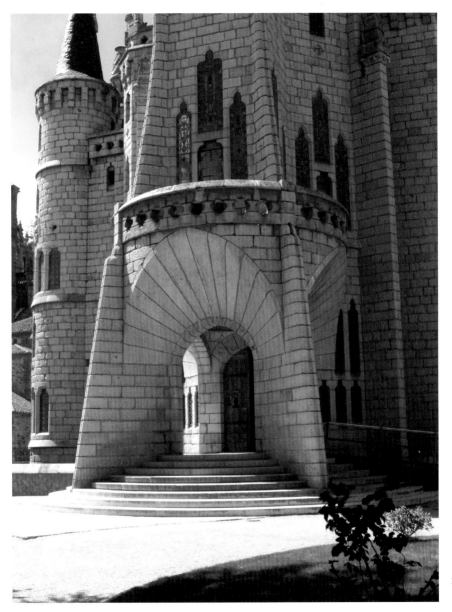

The ongoing celebrations and constructions of Gaudí the man by various groups signals how in our 'Post-Modern' age the ascetic, inspired, untiring creator remains a key trope of creativity in the popular imagination. Gaudí remains an enigmatic figure and attempts to interpret him tend to tell us more about the interpreter, as is illustrated in the following quotations. Salvador Dalí records an exchange with the architect Le Corbusier in his essay *As of the terrifying and edible beauty of modern-style architecture*. Dalí stated, "…that the last great genius of architecture was called Gaudí whose name in Catalan means 'enjoy'."

Episcopal Palace of Astorga
Chimney

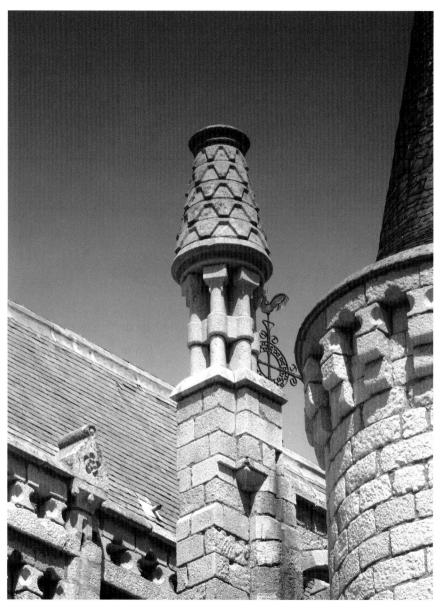

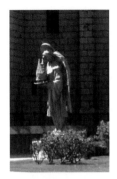

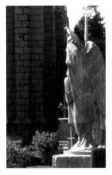

He comments that Le Corbusier's face signalled his disagreement but Dalí continued, arguing that "the enjoyment and desire [which] are characteristic of Catholicism and of the Mediterranean Gothic" were "reinvented and brought to their paroxysm by Gaudí". The notion of Gaudí and his architecture with which the Surrealist confronted the rational Modernist architect illustrates a recurring feature in the historiography of Gaudí, which is the concern to isolate Gaudí from the specific history of architecture and render him as a visionary genius.

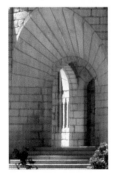

Episcopal Palace of Astorga

General view of façade

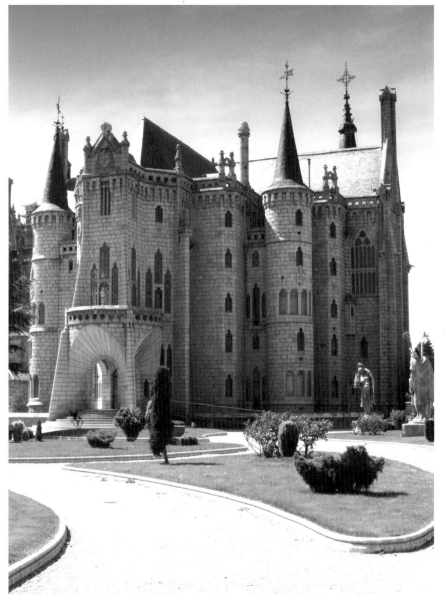

Furthermore, Dalí's account aims to place Gaudí in a pre-history of Surrealism and identify Gaudí as a 'prophet' or precursor of the aesthetics and ideas of that avant-garde Modernist movement. While the devout Catholic and studious architect Gaudí may have considered anathema much of Dalí's art and writing, he may not have disagreed entirely with Dalí's comments cited here. However, it should be noted that to identify Gaudí as a proto-Surrealist risks obscuring Gaudí's intellectual position, as well as his traditional religious beliefs. Considered from an historiographical angle Dalí's statement suggests an insight into Gaudí's continued appeal into the early twenty-first century.

Episcopal Palace of Astorga

Detail of stained glass windows

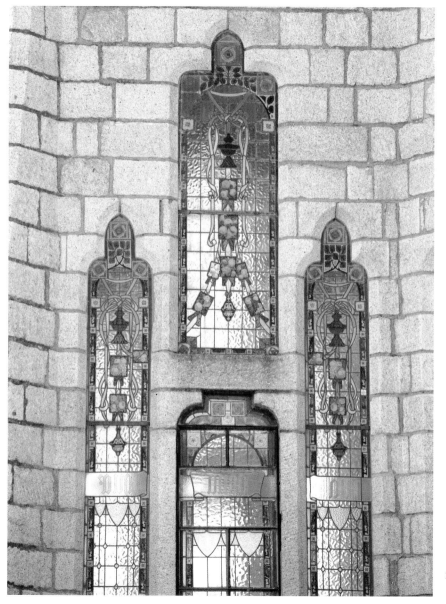

It may be argued that the frequent reappropriation and 'reinvention' of past styles in contemporary art, fashion and design has helped shape the appeal for Gaudí's artistic reappropriations, what Dalí termed his "paroxysm of the Gothic". It is of the utmost relevance to note that Le Corbusier was by no means antipathetic to Gaudí. In 1927 he is recorded as saying, "What I had seen in Barcelona was the work of a man of extraordinary force, faith, and technical capacity... Gaudí is 'the' constructor of 1900, the professional builder in stone, iron, or bricks. His glory is acknowledged today in his own country. Gaudí was a great artist. Only they remain and will endure who touch the sensitive hearts of men..."

Episcopal Palace of Astorga

Coat of arms detail on façade

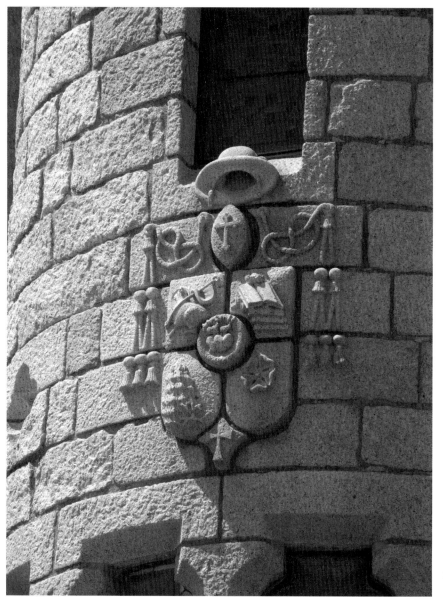

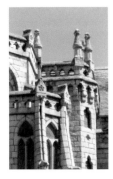

As will become apparent, Gaudí would have probably shared Le Corbusier's sentiments more than Dalí's. Le Corbusier's criticism signals a different approach to the analysis of Gaudí's work. It is examined in the specific context of architectural history. In the course of this book, analysis of Gaudí's buildings seeks to balance the measured architectural analysis evoked by Le Corbusier with discussion of the shifting critical responses to Gaudí's work such as Dalí's. The foundation for this approach is a critical understanding of Gaudí's life. His interests and the society of Barcelona, which shaped his work in important ways, need to be considered and they are the subjects to be treated here.

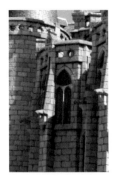

Episcopal Palace of Astorga

View from behind

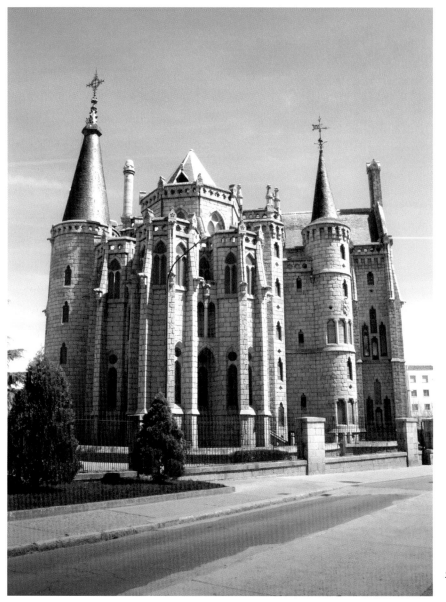

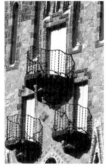

It needs to be emphasised that in the absence of further information it is the buildings which are the best testament to the man. Although Gaudí was not born in Barcelona, the city which provided a key cultural dynamic to his architecture, he was born in Catalonia, in the small town of Reus. Biographers of Gaudí, often prompted by the architect himself, have identified in his provincial childhood experiences the origins of his later creativity. The belief that art may be an inherited gift underpins Gaudí's assertion that his "quality of spatial apprehension" was inherited from the three generations of coppersmiths on his father's side of the family, as well as a mariner on his mother's side.

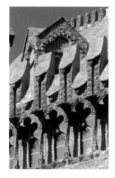

Tower of Bellesguard

View of the West side

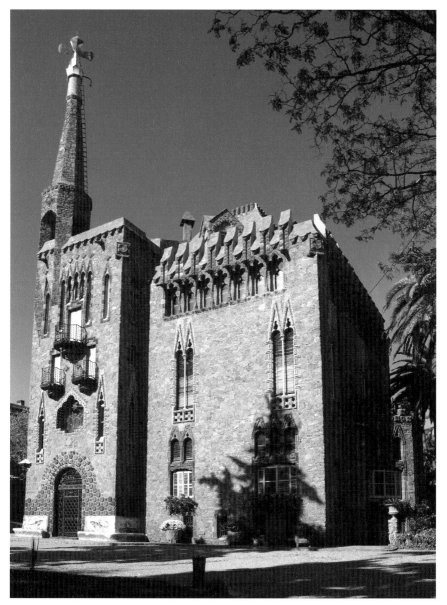

Whatever truth there may be in Gaudí's claim, we can be certain that his home life was comfortable and stable. The only shadow cast over his childhood was a period of severe illness. The psychological effects of this on the development of the young child's imaginative faculties and spiritual convictions are hard to gauge, although his survival may be read as an early sign of a strong constitution and defiant determination. It can be asserted with more confidence that this period of Gaudí's life introduced him to four factors that would be fundamental to his career: architecture, especially the Gothic;

Tower of Bellesguard

Ceramic mosaïc on the entrance bench

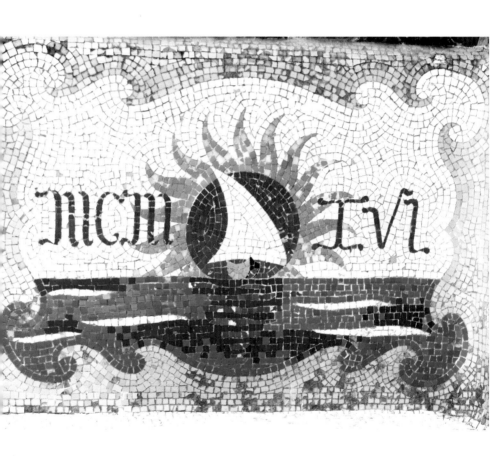

Catalan history and culture; Catholic doctrine and piety; and, finally, the forms and colours of the natural world. In many ways architecture acted as a medium to explore and reflect on the latter three. Besides the traces of Reus's medieval heritage, the neighbouring towns and countryside provided a number of important buildings to visit, such as the famed pilgrimage Church of Montserrat and Tarragona's impressive cathedral. Gaudí's experiences of such places would have been coloured by an awareness of them as the cultural patrimony not of Spain, but the region of Catalonia, of which Barcelona is the capital.

Tower of Bellesguard

Bench detail (the fish with four bars represent
the former naval powers of Catalonia)

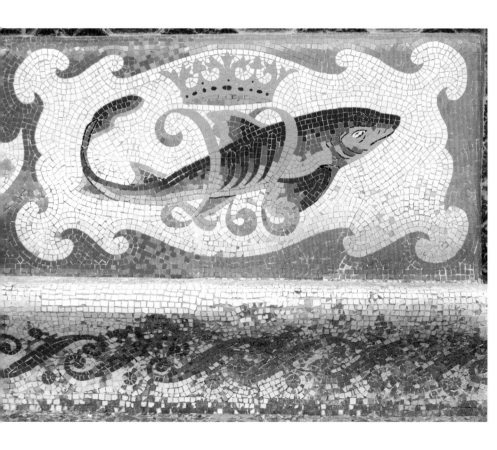

Catalonia had once been part of the independent Kingdom of Aragon, which first became linked to the Kingdom of Castile to form what we know as modern Spain in the fifteenth century. The process of balancing unification with regional autonomy is still being negotiated today and as a result Catalonia has developed a strong sense of national identity, with Barcelona at its centre. The fact that many of the buildings Gaudí visited were religious is a reminder of the particular role that religion played in the construction of Catalan identity, as it did in the histories of other regions of Spain.

Tower of Bellesguard

Bench detail (the fish with four bars represent the former naval powers of Catalonia)

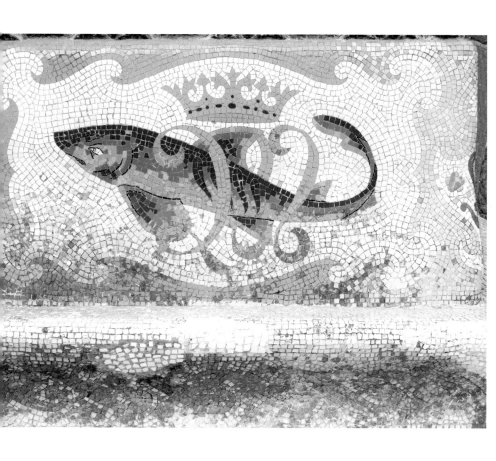

As an adult, Gaudí would identify with both a defiant form of Catalan nationalism and a devout commitment to the Catholic Church. However, as a child and youth such serious concerns were a long way off.

Nonetheless, a keen youthful interest in architectural history and a concern for Catalan patrimony provided a foundation for his later ideological position. Besides visiting existing buildings Gaudí, accompanied by friends, would also seek out the ruins of once-great buildings and the traces of Catalonia's history.

Tower of Bellesguard

Detail of entrance tiles (Lions and roosters, symbols of royal powers)

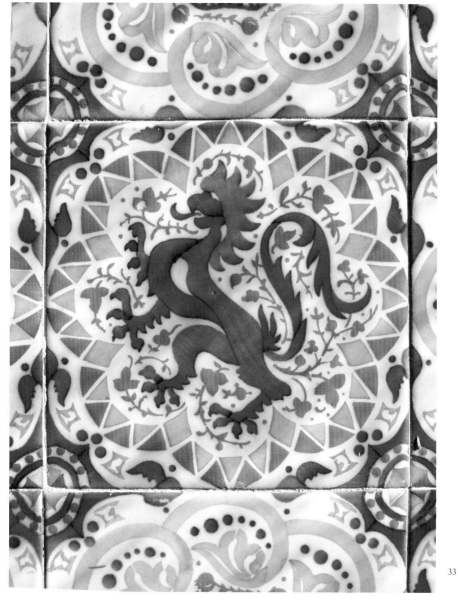

33

It would not seem fanciful to suggest that these excursions into the countryside inspired in Gaudí a creative vision of the landscape, stone, plants and other elements of the natural world. There is little verbal testimony of Gaudí's youthful attitudes to nature, and we must wait to examine his architecture to gauge this aspect of his thinking. However, the clearest identification of the early signs of Gaudí's creative and intellectual powers are exemplified by an important episode from his youth, his involvement in a project to restore the ruined Cistercian monastery of Poblet.

Tower of Bellesguard

Rooftop walkway

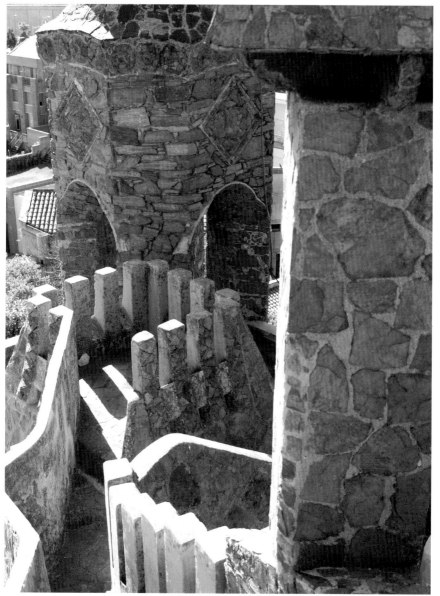

In 1867, accompanied by his childhood friends Eduardo Toda and José Ribera Sans, Gaudí visited the ruins of the twelfth-century monastery. Documentary evidence of their visits records their imaginative impressions: the *Manuscrito de Poblet*, written by Toda in 1870, lists their plans to restore the crumbling remains into an utopian cooperative, attracting the necessary labour force as well as a community of artists and writers, the combination of which would restore the monastery to a new life.

Tower of Bellesguard

Rib structures of the ceiling on the second floor

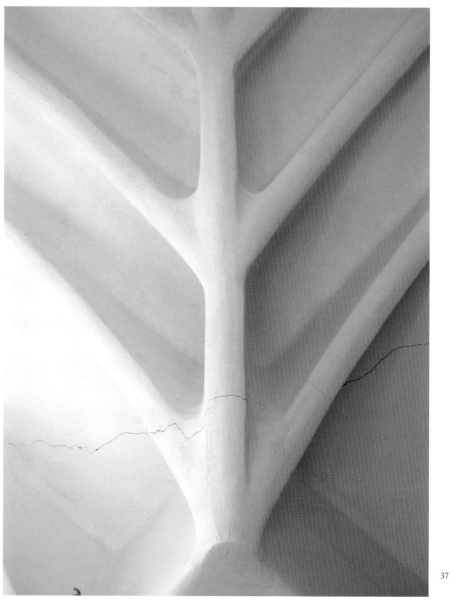

However, their youthful spirits were captured by the monastic ideal with art, life and pleasure as guiding principles, rather than by the restoration of Catholic tradition. It is worth noting that the *Manuscrito de Poblet* records the first known drawing by Gaudí of the heraldic shield of Poblet, which was produced in 1870. In the 1930s Toda would return and lead the restoration of this monastery, but by that time Gaudí had been dead for four years. The intervening years had been spent by Gaudí not simply in imaginative restorations of the ruins, but in a creative and innovative interpretation of the architectural language of the past, as well as its values.

Tower of Bellesguard

Rib structures of the ceiling on the second floor

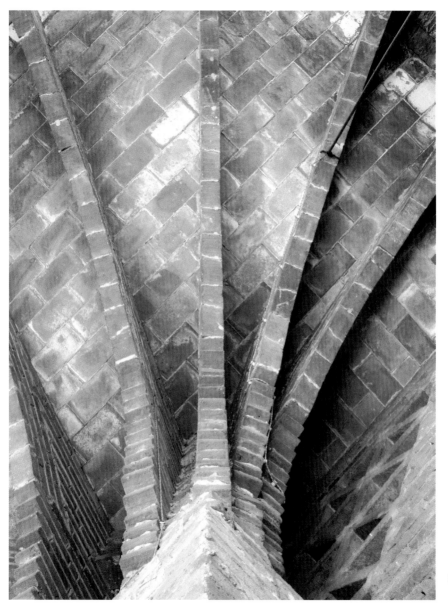

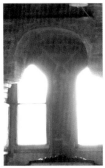

It was as a student in Barcelona that this artistic process was initiated in earnest. Gaudí's life in Barcelona began in the autumn of 1868. His elder brother, Francesc, was already there by then, studying medicine. During his first year he completed the final two compulsory courses of his secondary education at the Instituto de Jaume Baulmes. However, one may also assume that he spent considerable time discovering Barcelona's architecture, both old and new. The following year Gaudí, aged 17, enrolled in the Science Faculty at the University of Barcelona.

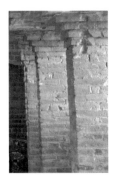

Tower of Bellesguard

Detail of trilobite arches in parabolic
form in the first attic

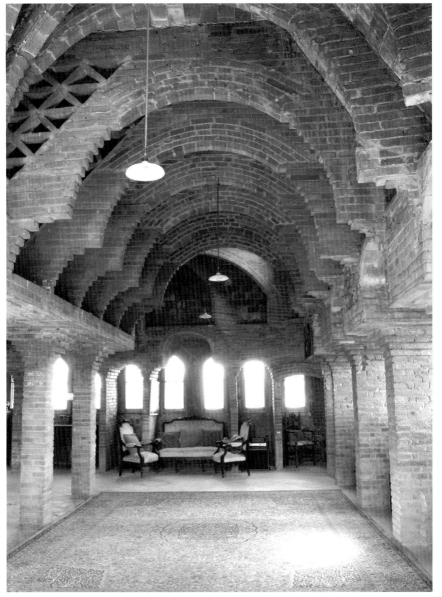

41

The five-year course that he attended covered various branches of mathematics as well as chemistry, physics and geography. His university results offer one means to measure Gaudí's intellectual ability. He passed, although had to retake his final year before entering the School of Architecture in 1874. Testimony from fellow students record his commitment to study, yet also the difficulties he encountered especially in theoretical subjects such as geometry. The image of the student Gaudí that emerges from his biographers is a thinker who relished work in a practical context, but found theoretical and abstract principles both challenging and tedious.

Tower of Bellesguard

Lobby

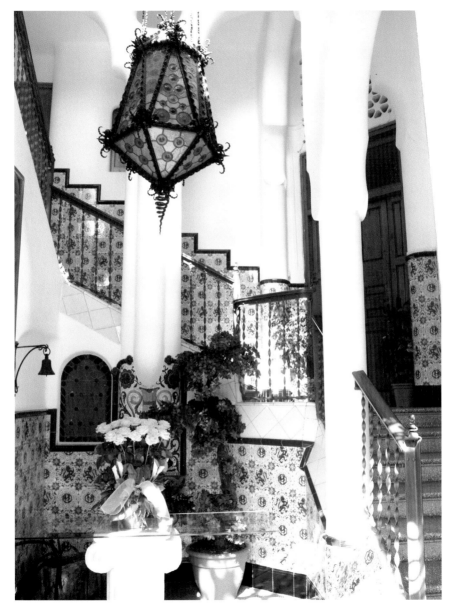

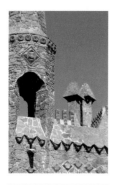

Gaudí's practical approach to solving complex architectonic problems, as opposed to drawing on mathematical solutions, is notable in his mature work, when he would employ models to develop his ideas. However, Gaudí's mind was not only scientific. Prior to being accepted at the School of Architecture he had to prove himself at both architectural and life drawing. While no less was to be expected of an architecture student he also passed the school's French language test. He clearly had some ability in languages as well as literature.

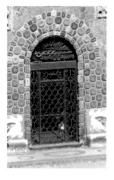

Tower of Bellesguard

South side

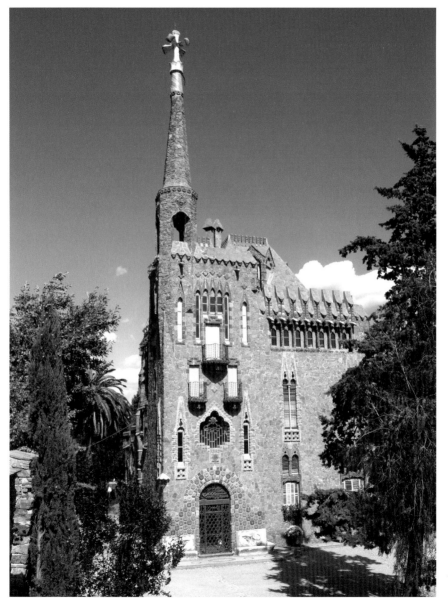

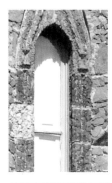

In the course of his life he mastered German and was an avid reader of Goethe's poetry, much of which he knew by heart! Thus the profile offered by Gaudí's academic record reveals a broad range of abilities. Perhaps more important is that these were accompanied by an avid enthusiasm for learning, in particular with regard to his chosen discipline. Study in the School of Architecture was structured firstly through academic courses in drawing skills for preparing architectural plans and designs and in gaining a knowledge of building materials.

Tower of Bellesguard

Building detail (gothic window)

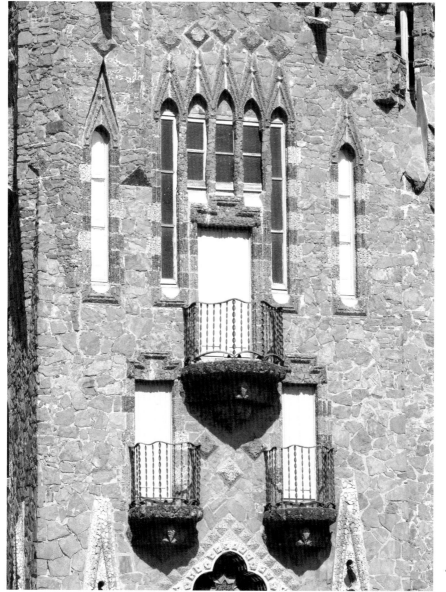

In conjunction with these taught courses students also put their work into practice. Between 1874 and 1875 Gaudí's projects included the design for a candelabrum, a water tower and, most notably, a cemetery gate. The following year his studies were interrupted by conscription to the army. Although Gaudí was decorated for his defence of the nation it seems he did not actually see action. The following year his projects were more taxing, having to design a patio for local government offices as well as a pavilion for the Spanish exhibit at one of the many grand international exhibitions that took place in Philadelphia.

Casa Calvet

General view

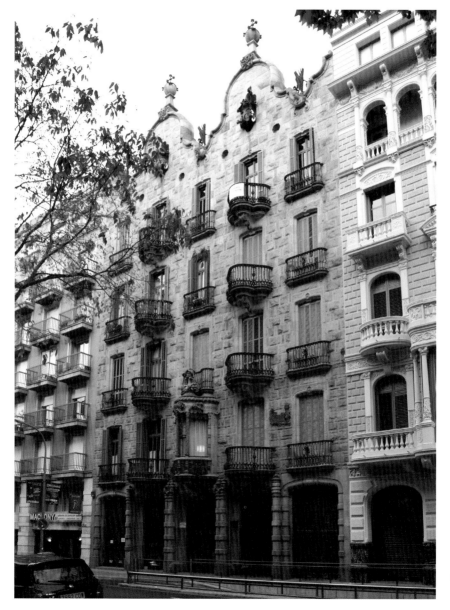

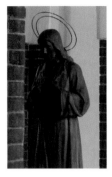

In the course of his student career he would also work on a shrine for the Virgin of Montserrat, designs for a hospital, a boating lake, a fountain and a holiday chalet. Having carried out this range of designs, Gaudí was trained to work from the small scale to the monumental, as well as being prepared to satisfy the different demands of potential clients, from institutional to ecclesiastical buildings and public to private spaces. As this range of work testifies, Gaudí's student years were an extremely hard-working and productive period.

Theresan College

Brick work columns on the first floor

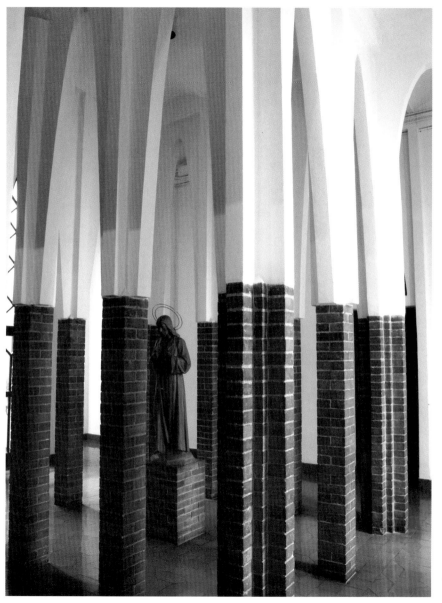

51

Of the few graphic and design works that have survived until today a number were part of his student projects. Although these works demonstrate his affiliation with the principles and ideas of his teachers, which are discussed in the following chapter, they mark the start of his career and highlight the dramatic changes he introduced into the practice of architecture. Despite the classical simplicity of the 1875 design for Gaudí's cemetery-gate project, it is interesting to note the integration of sculptures and ironwork which would become central features of his later work.

Casa Calvet

Insect door knocker

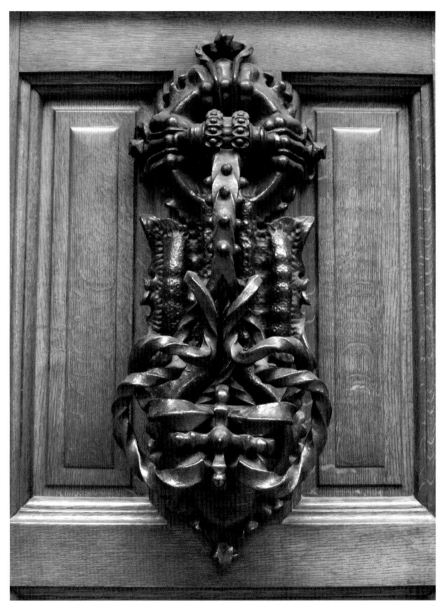

Six angels line the sides of the archway, the two iron gates meet at a sculptural group of the Crucifixion with the Virgin and St. John the Baptist. Above, in the centre of the arch, is the figure of Christ as Judge of mankind and crowning the structure is the enthroned figure of God. Combined with other elements Gaudí created an iconographic programme based on the book of Revelation, the last book of the bible which recounts the mystical and eschatological visions of St. John the Evangelist.

Casa Calvet

Anagram detail

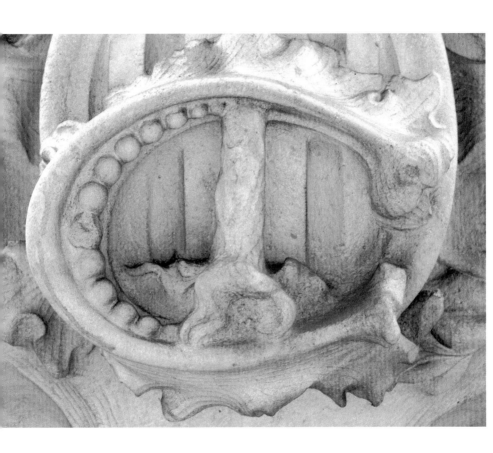

The addition of the flaming beacons on the four corners and what appears to be a censer, for incense, signals his interest in effects of light and organic forms of flame and smoke. Gaudí failed his assignment for this design as its descriptive setting was not considered the correct procedure for an architect!

Gaudí's skills as a draughtsman are remarkable, and Gaudí's teachers did recognise this even though they questioned some of his techniques. In his course of studies he was awarded an honour grade and was thus eligible to compete for a school prize.

Theresan College

General view

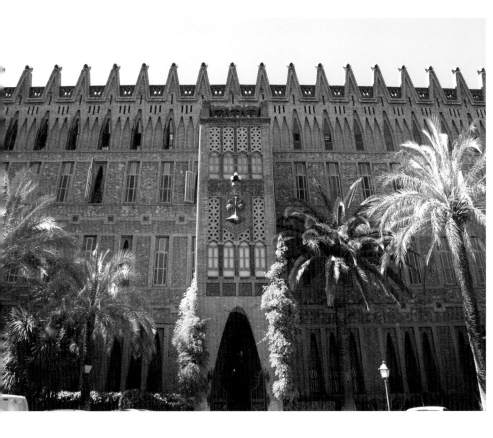

The project he entered for the competition was an elaborate lakeside pier, with steps to the water to board pleasure boats. It combines an elegant yet elaborate arcade of Gothic arches above which rise two cylindrical towers. The lakeside promenade is decorated with sculptures stood on pedestals, which are linked by a wrought-iron balustrade. Out of recognition of his teachers' strictures on the principles of drawing, the references to reality are almost all but eliminated: faint touches of watercolour evoke the lake's surface and a boat comes into dock. Closer study reveals the wealth of detail with which Gaudí imagined this building.

Theresan College

Corner view of building with the original coat of arms

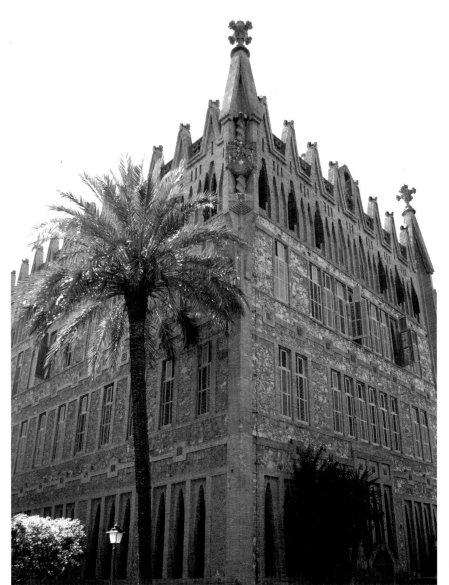

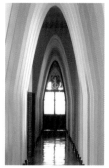

Such attention to detail indicates the dedication of the young trainee architect, and the pressure of Gaudí's workload during this period was added to by the need to support his studies by working for a number of architectural practices. Despite the challenges this must have posed, not to mention the emotional strain of the deaths of both his mother and elder brother, all of which he overcame through pure hard work, he finally qualified as an architect in 1878. However, there was a dispute between the lecturers over his qualification, which may signal that his excessive workload distracted him from his studies.

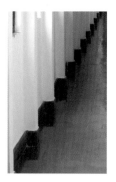

Theresan College

Cloister arches

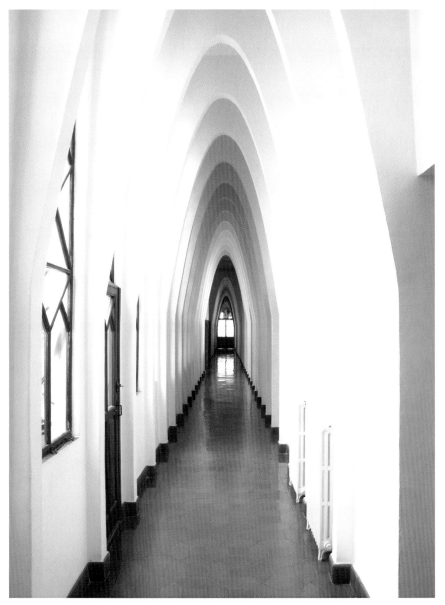

On announcing to Gaudí his graduation Rogent, the director of the School of Architecture, declared, "Gentlemen, we are here today either in the presence of a genius or a madman!" A disgruntled Gaudí is recorded as answering, "So now it appears I am an architect." It is interesting to note that the notion of genius was applied so early to Gaudí and his work, yet it is unfortunate that there is not sufficient evidence to identify why Gaudí was judged as departing from the norm established by his lecturers and followed by his peers.

Theresan College

View of corridor, entrance hall

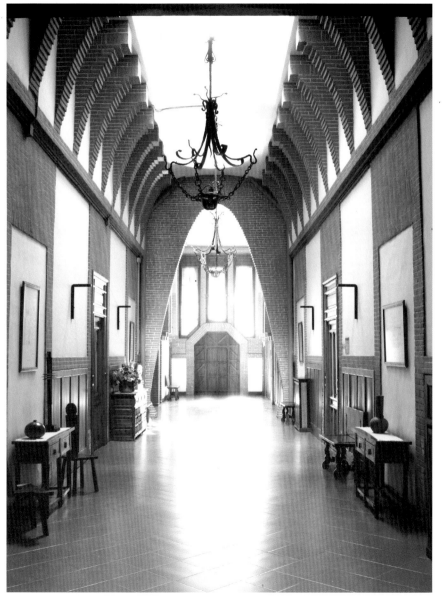

Nonetheless, as Gaudí's attitudes to authority later in his career indicate, his personality was marked by a highly confident belief in himself and his work. However, Gaudí's belligerence is one dimension of his character, and while it indicates his sense of self-worth it tells us less about his architecture. One of the defining aspects of Gaudí's style is his imaginative response to the forms and styles of architectural traditions. Through juxtaposition, transformation and reinvention he would employ traditional architectural motifs and styles in original and creative ways in his mature work.

Theresan College

Coat of arms

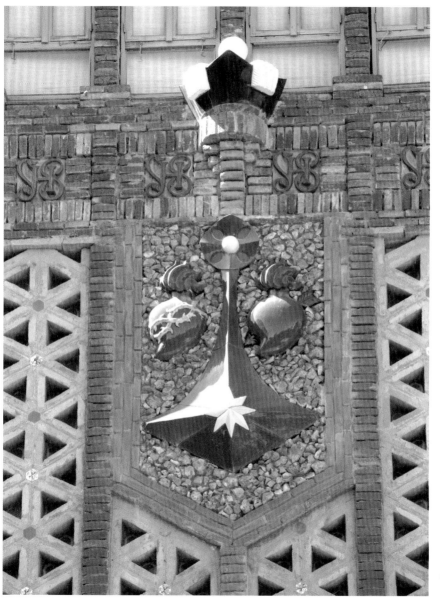

The School of Architecture provided an intellectual and ideological context for Gaudí to begin thinking along these lines, in terms of the latest theories of architectural practice. These themes provide a key perspective to understanding the development of Barcelona's particular brand of European modernism. Gaudí's own thoughts and opinions need to be discerned from his actions and associations with his contemporaries. Unfortunately, the existing correspondence is limited and Gaudí was not inclined to turn to writing as a means of expression.

Theresan College

Entrance

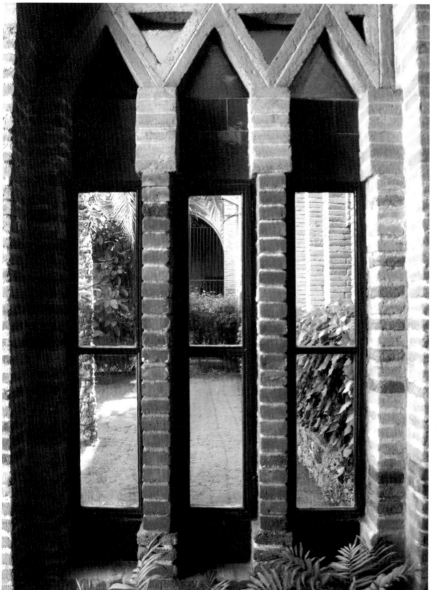

He stated in 1913 that, "Men may be divided into two types: men of words and men of action. The first speak, the latter act. I am of the second group. I lack the means to express myself adequately. I would not be able to explain to anyone my artistic concepts. I have not concretised them. I have never had the time to reflect on them. My hours have been spent in my work."

Although statements by artists, architects, composers and writers as well as other public figures need to be read with a critical attention to detail, this statement contains more than a grain of truth.

Theresan College

Main entrance

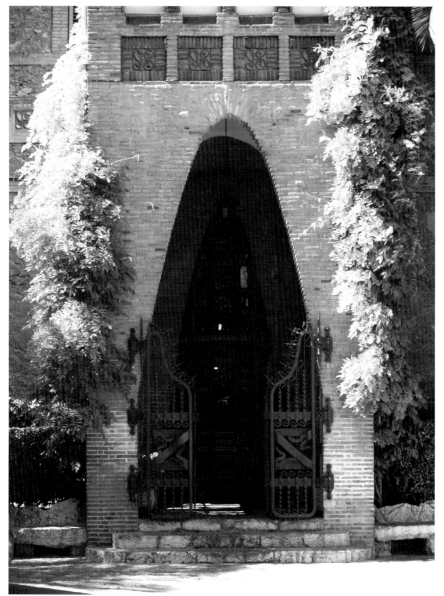

Firstly, except for some youthful writings produced between 1876 and 1881, Gaudí demonstrated no concern to theorise his architecture. Nor did he become a teacher in the academic or university sense, except in the very practical sense of instructing and working alongside his team of assistants, fellow architects and other craftsmen. Secondly, Gaudí never allowed himself enough time away from the many projects he worked on to analyse the ideas that shaped his working practice. However, there are a scattering of statements from Gaudí from the final decade of his life which, together with the early writings, offer suggestive insights into his buildings, as will be seen later.

Theresan College

View of façade, window detail

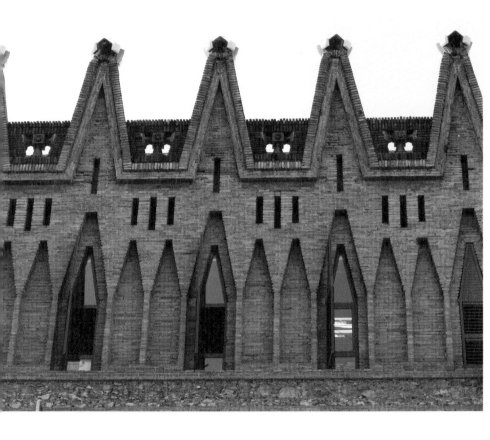

A curious autobiographical statement by Gaudí is the desk that he designed and had built for himself in 1878. It is one of the few objects in his whole oeuvre that combines a personal written statement with drawings. Unfortunately, the desk itself is only known through photographs. The desk is a refined advertisement of his skills as a designer, in which capacity he would soon undertake a number of commissions. It also shows his interest in combining decoration with architectural elements. In his writing he provides a detailed account of the many elements that made up this desk, such as many animals, plant and other organic forms.

Theresan College

Entrance hall

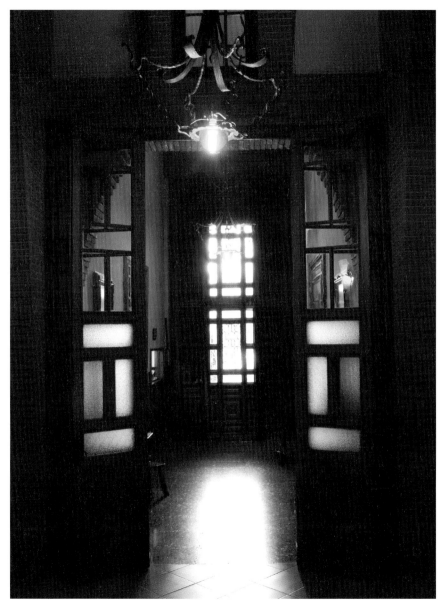

An important principle for combining decoration with the structural elements of the desk is explicitly made in his description of it:

"It frequently occurs that when ideas are combined with one another they diminish and are obscured. Simplicity gives them importance."

Even in the complexity of the Sagrada Familia, Gaudí's ability to maintain dialectic between simplicity of form and the richness of his ideas would be upheld. Gaudí certainly appears to have been consistent to the few principles he did clearly state.

Theresan College

First floor room

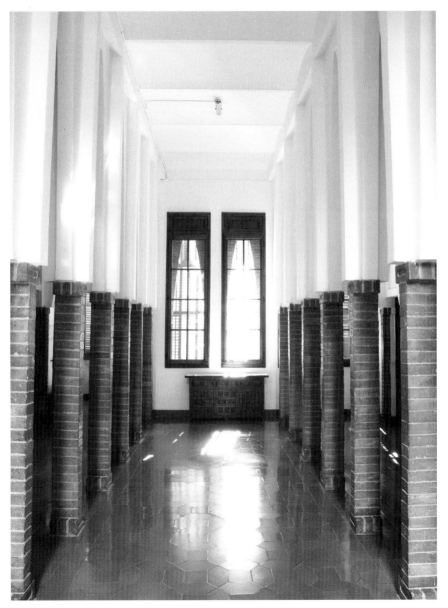

While his architectural skills were being learnt, tested and refined Gaudí swiftly made the transition to the customs and fashions of Barcelona and its student community. Anecdotes record Gaudí's well dressed and manicured image during his student days. The extra paid work he took on was perhaps encouraged by the social pressures to maintain this fashionable image, and it seems probable that a copper-smith's son would feel proud to be well dressed. Gaudí's sartorial elegance has been subjected to critical scrutiny by biographers for the contrast they offer to his later ascetic life.

Güell Crypt

Window

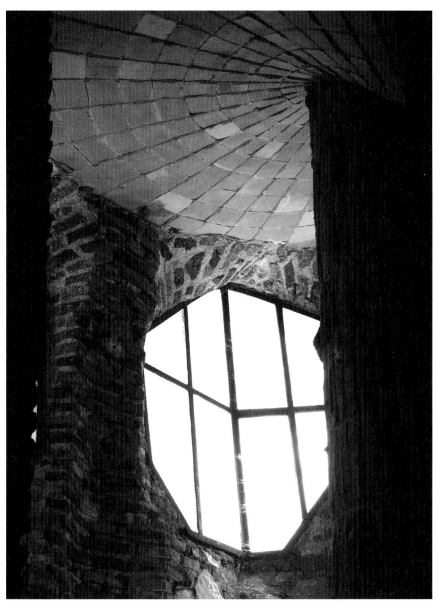

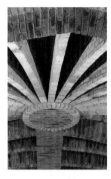

However, the fact that he discarded the suits and dressed in a humble manner is more significant than the fact that he wore them and the best indication of what Gaudí would become is best shown by his dedication to work. In addition, personal appearance would have been influential in making his way in Barcelona society, especially amongst his prospective patrons. Gaudí's 1878 design for a business card is worth noting in this regard too. The elegant art nouveau script with the floral flourishes on the letter 'A' is a subtle promotion of his skills.

Güell Crypt

Cupola of the main hall

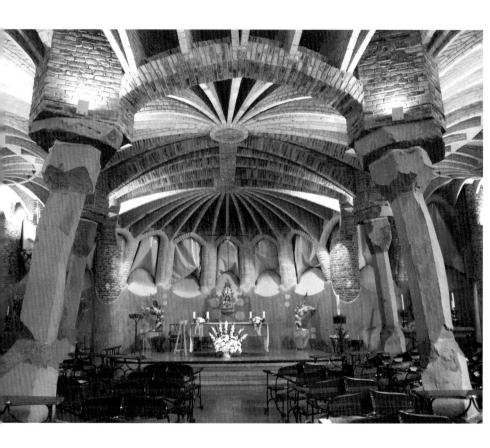

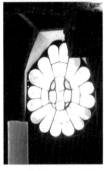

The friendships and professional relationships Gaudí made show how his skills and intelligence were swiftly recognised in Barcelona. He designed a house for his close friend and medical advisor Dr. Santaló. In comparison to the more rigid class system of Britain it is interesting to see how the son of provincial boiler-maker could strike up a relationship with one of Barcelona's wealthiest men, Don Eusebio Güell. Statements by Gaudí about Güell suggest the relationship was marked by deference on the architect's part, yet they shared common interests in the culture and heritage of Catalonia, and of course, in architecture.

Güell Crypt

Ceiling

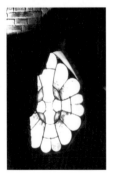

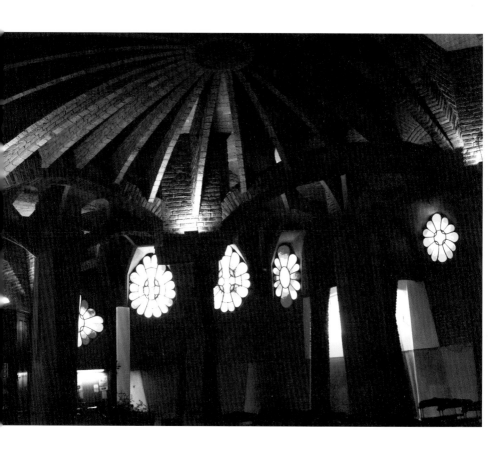

As well as Gaudí's headstrong character and individualism which emerged in his student years, so too did his commitment to the defence of Catalan culture and tradition. With time his architecture would become an expression of this, however it was a sentiment he supported in other ways too. From his youthful interest in the history of Catalonia Gaudí developed into a staunch defender of the region and its values, which he remained even in the final years of his life. In 1920, when the police attempted to prevent a traditional literary contest, he took a beating from their truncheons and then turned to shout insults in response.

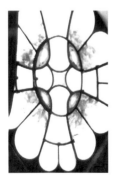

Güell Crypt

Interior

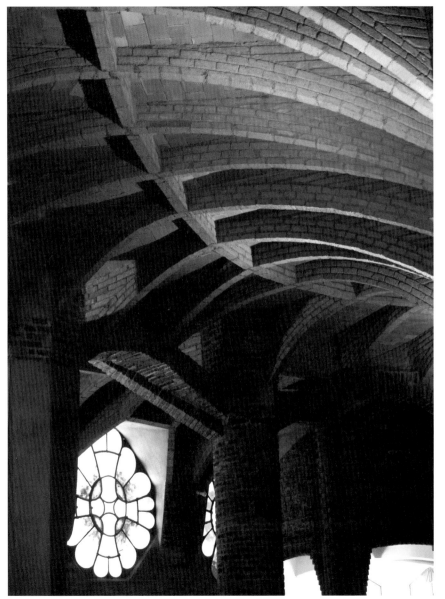

83

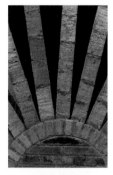

Four years later he was arrested for protesting against the police's obstruction of the celebration of a mass in honour of eighteenth-century Catalan martyrs. Gaudí was not involved in political action against the police and state all of his life. With Spain's unstable political situation subject to periodic change so too was support for Catalan autonomy, and the freedom to celebrate its values. In any case over the course of his life he shied away from direct political action. In 1907, when the political party *Solidaritat Catalana* was attracting great support, pressure was put on the architect to contribute to the political sphere.

Güell Crypt

Ceiling detail

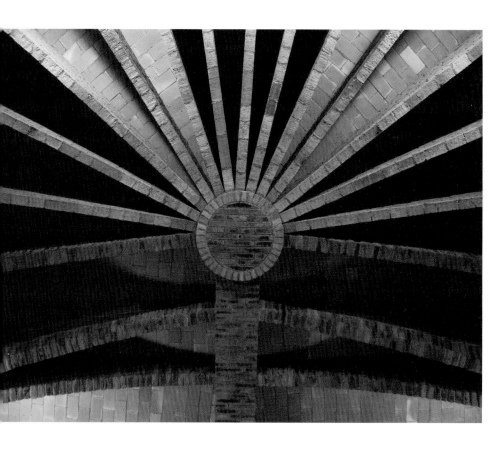

At that time he was working on his last great domestic project, the Casa Milà. He refused to be distracted from his work. For Gaudí, politics were understood in a broad cultural sense and intimately related with his architecture. Furthermore, during this period which witnessed the development of revolutionary political movements, Gaudí maintained a conservative position. He was certainly no advocate of violence. The mixture of his nationalist sentiment, conservative concern for tradition, and religious views produced a paternalistic view of society.

Güell Crypt

Stained glass window

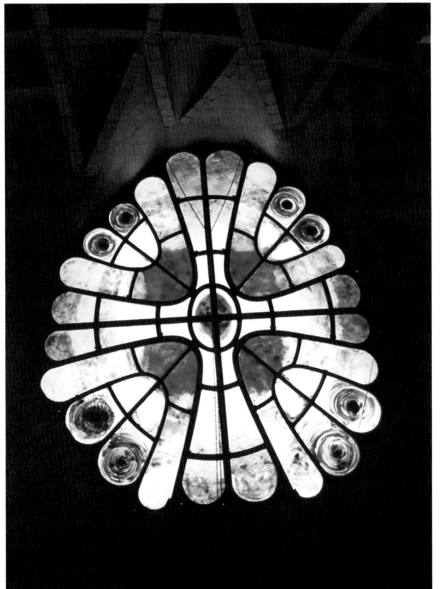

He frequently asserted his respect and commitment to the working classes, but believed that it was the duty of the employers and Church to assure decent working and living conditions and social order based on Christian morality. Perspectives of Gaudí's views of society are best judged from the different buildings he designed for the wealthy patrons and their workers, the church authorities and their congregation.

The year after Gaudí qualified as an architect he joined a more peaceful organisation devoted to the Catalonia's cultural traditions. This was the Associació Catalinista d'Excursiones Científicas.

Güell Crypt

Detail of outside of entrance

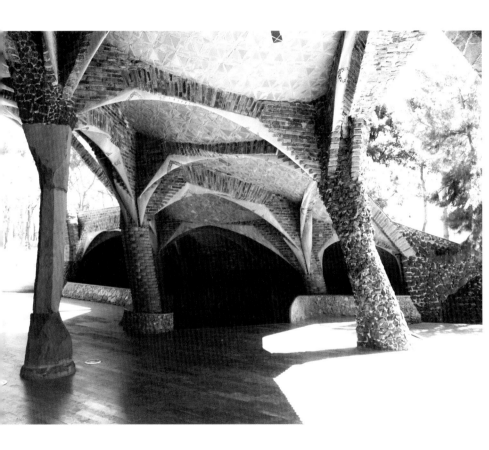

The aims of the organisation, established in 1876, were broad. As the name suggests, its central activity was visiting the countryside and sites of cultural interest. It is a good example of the nineteenth-century belief in a healthy body and a healthy mind, as well as the middle-class suspicion that city life could have harmful effects on one's moral condition. Walking in the countryside and visiting sites of historical interest with like-minded male companions was the solution to the latter. The association also had a clubhouse in the centre of Barcelona with a library, which was the venue for lectures on the diversity of Catalonia's culture as well as aspects of its economy.

Güell Crypt

Detail of outside of entrance

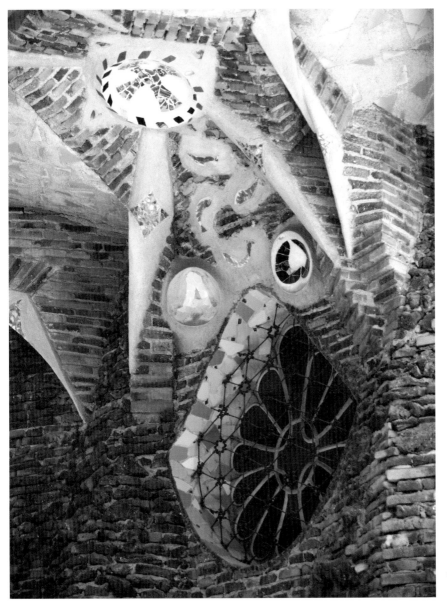

Both were important factors in Catalonia's claim for independence. On the day of St George, the patron saint of Barcelona, the clubhouse was the focus of patriotic celebrations. Gaudí's first 'excursion' with the association was to Barcelona's cathedral, not too exhausting a journey by foot! Subsequent visits went further afield. In different ways Gaudí's participation in this organisation contributed to his architecture. The most obvious connection is through all the visits made to look at and study buildings. However, rather than planning new buildings, the concern that motivated many of these visits was to restore forgotten or crumbling monuments.

Güell Crypt

Façade

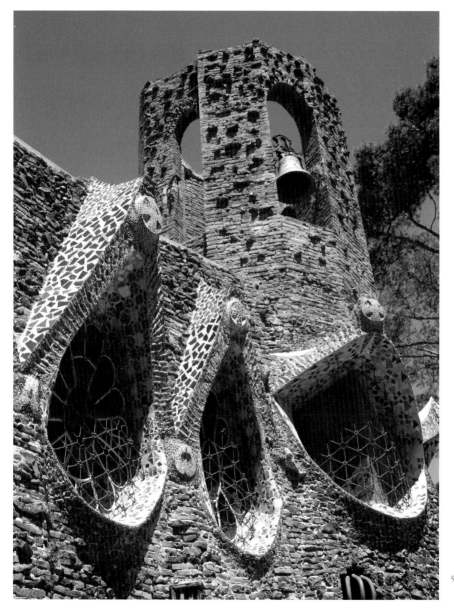

After some visits reports were sent to government officials to encourage restoration projects to be undertaken. So in many ways the association continued the idealistic vision of Gaudí and his childhood companions at Poblet. Later in his life Gaudí would take on the huge restoration project of Mallorca cathedral. Today, Gaudí's work is very much identified as an image of Barcelona, in his own lifetime he strove to develop an architecture that drew on and revived the traditions of his homeland. The excursions to buildings must have been accompanied by reflection on the architectural traditions of the region.

Güell Crypt

Detail of outside column

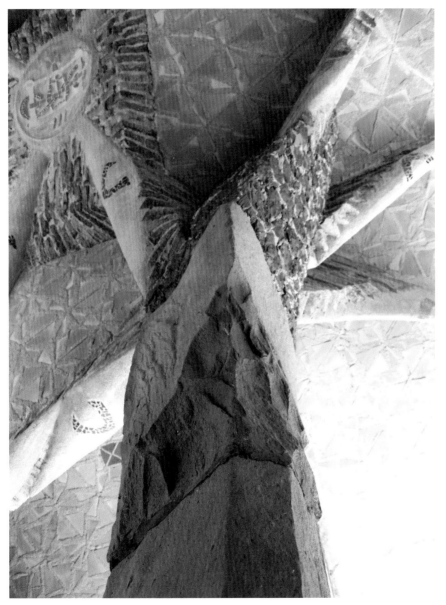

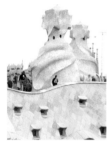

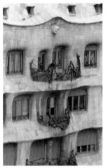

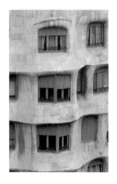

Without doubt, study of Catalan heritage was focused through his architectural studies, but it would seem probable that the zealous and idealistic visits of the association offered a further creative impulse. Furthermore, other architects were also members, such as Domènech about whom more will be said later on. Besides making contact with his peers, the association also provided the opportunity for Gaudí to develop his friendship with Esuebio Güell, who was also a member. The fact that architects and their patrons came together in the association reveals the range of people it attracted and signals that it was an important space for the generation of cultural projects.

Casa Milà

Façade

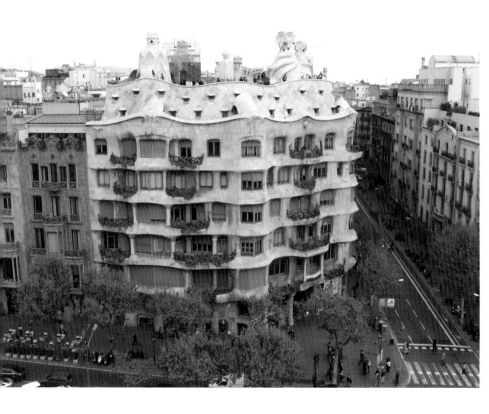

Gaudí's activities with this association, as well as a similar group, the *Associació d'Excursiones Catalana*, were limited by his work, which after the mid 1880s curtailed his involvement. Yet Gaudí remained in touch with the political and cultural debates generated by Catalan society through his friends, patrons and the other seminal dimension to Gaudí the man, which was his religious belief. Catalan nationalism took various guises reflecting the political spectrum. Gaudí sided with the conservative wing and as a result the traditions of the Church, such as the devotion to Catalan saints, were an important focus for him.

Casa Milà

Window detail view from the courtyard

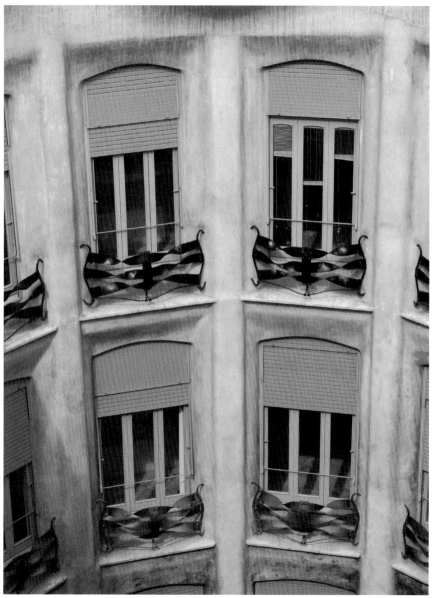

Working on the Sagrada Familia, which would become his crowning achievement in the field of ecclesiastical architecture, despite remaining unfinished, Gaudí came into contact with another association, the *Associación Espiritual de Devotos de San José*. The formation of these voluntary organisations with a pedagogical or social remit was a Europe-wide phenomenon. The association was led by José María Bocabella Verdaguer, whose meditations at the mountain church of Montserrat guided him to found the association.

Casa Milà

Entrance hall column detail

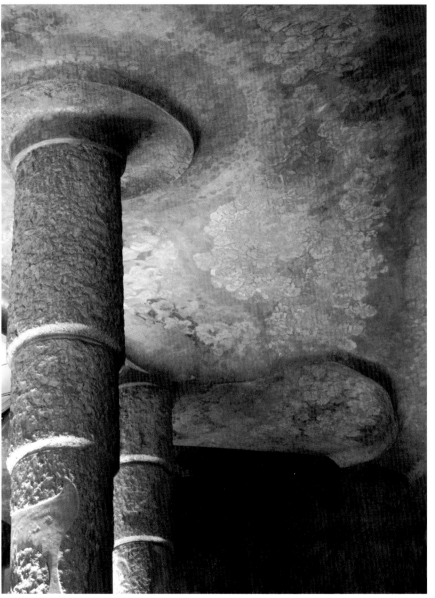

Publishing religious propaganda was a central activity of the association in its drive to defend traditional Catholic values against atheism, socialist and anarchist political ideas, and the immorality that accompanied the rapid growth of Barcelona as well as other European cities. Gaudí's connection to Bocabella will be discussed in more detail later, but it would be wrong to identify Gaudí solely with this religious group, which was only one part of a greater movement to revive the faith and status of the Catholic Church in the modern world. Furthermore, Gaudí's religious beliefs are more complex.

Casa Milà

———

Staircase in roof tower

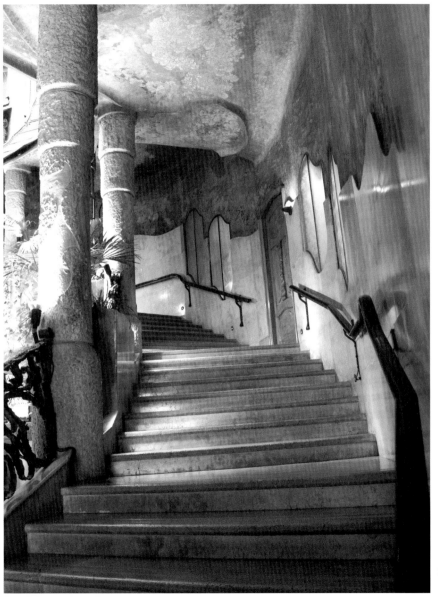

They may be traced back to his traditional upbringing and Van Hensenbergen has also argued that his religious belief, as well as that of many of his intellectual peers, was coloured by a perceived connection between spirituality and aesthetic pleasure and sensation. The Catholic Church has always recognised the role of the visual and literary arts, and shown its dexterity to incorporate, as well as guide, changes in style and expression. Following Van Hensenbergen's thesis it may be argued that Gaudí's work marks a significant chapter in developing a modern aesthetic for the Catholic Church.

Casa Milà

Entrance hall column detail

Yet it is important to note that his vision was as much if not more of the Gothic world as the modern. Gaudí's religiosity signals his distance from concepts of modernity. The historian Cirlot records the following definition of art by Gaudí:

"Art is something so elevated that it has to be accompanied by pain or misery to provide a counterweight in man; if not, it would deny any equilibrium."

The status Gaudí gives to art identifies his thinking as modernist yet that it should be balanced by pain or misery suggests that his philosophy of art is framed by Catholic doctrine and its emphasis on original sin.

Casa Milà

Entrance hall column detail

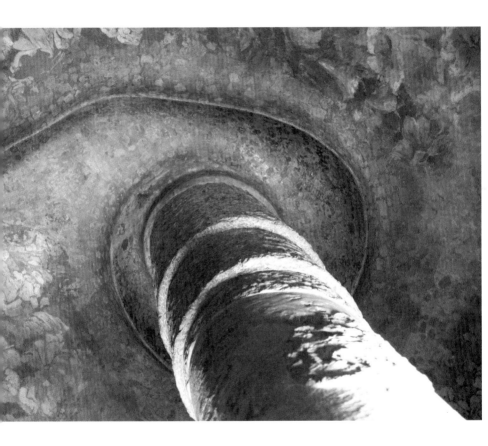

The dialectic he evokes does imply an existential dimension to his work, yet Gaudí always sought to elevate the beholder beyond the trappings of existence to the spiritual world. Such concerns underpin his reworking of the Gothic style, which was radical in many ways, but was also shaped by a concern to sustain the traditions both architectural and metaphysical of the medieval period. Another example of the religious dimensions of Gaudí's thinking is his opinion, frequently cited, that "beauty is the radiance of truth." A theological truth is implied here. Without doubt this view of the past was 'rose-tinted'. Gaudí was not alone in this vision of an ideal medieval society.

Casa Milà

Detail of inside roof timbers

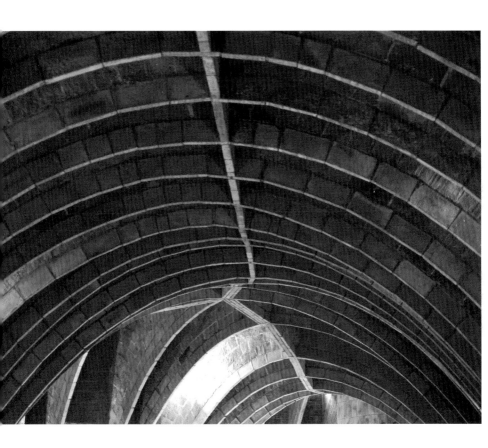

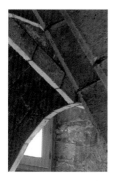

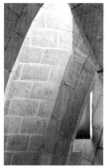

In Britain Ruskin and William Morris looked to the medieval era for ideals of both artistic work and social organisation which would result in a moral and harmonious society. Gaudí's buildings for Güell illustrate the religious and utopian vision that architect and patron shared. The medieval world view evoked by Gaudí's work is also encountered in the allusions to palaces and castles of his domestic architecture for his wealthy patrons, the factory and the warehouse having become the modern fiefdoms. Although today discussion of such utopian ideals might appear naïve to modern visitors, their evocation in stone, space and light remains powerful.

Casa Milà

Detail of inside roof timbers

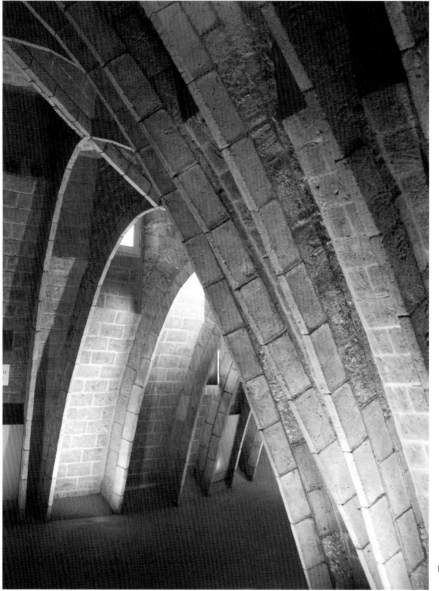

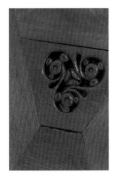

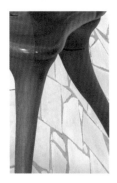

Another aspect of Gaudí's traditional outlook is noted in the way he organised his workshop with its many craftsmen. In addition to the emphasis placed on the use of manual skills, Gaudí maintained long working relationships with a range of architects such as Berenguer or Jujol, who both went on to become important independent architects in their own right. As well as his equals in terms of education, Gaudí commanded respect from all of his team of assistants and he is recorded as being a strict but fair overseer. His paternalistic attitudes are noted for example in his encouragement of the workers not to drink alcohol and the allotting of lighter duties for the elder workers.

Casa Milà

Sculpted chairs designed by Gaudi

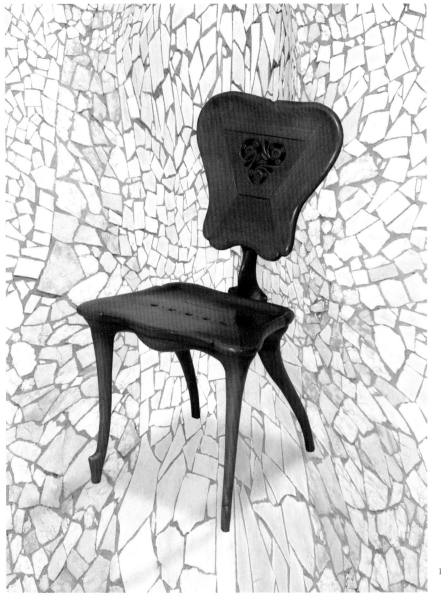

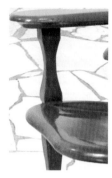

A detailed study of the religious circles Gaudí frequented during his life remains to be undertaken. An additional association he was connected with was the *Cercle Artístic de Sant Lluc*. St Luke is the traditional patron saint of painters and this group, founded in 1894 by the sculptor Josep Lilmona, sought to promote Catholic art, as well as to counter the immoral avant-garde activities of Barcelona's *modernista* artists, such as Picasso. Gaudí became a member in 1899. It is apparent that art was a fiercely contested space in Barcelona between those wanting to preserve tradition and their adversaries wanting to overthrow it. A number of caricatures explicitly parody Gaudí's religious beliefs, including a drawing by Picasso.

Casa Milà

Sculpted chairs designed by Gaudi

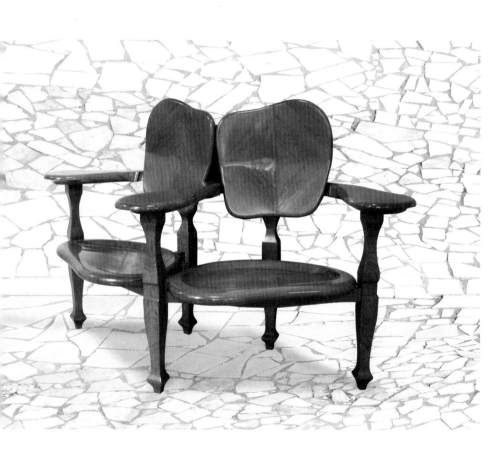

In any case, a cautious approach is required to focus more closely on the relationships between Gaudí and Barcelona's Catholic intellectual fraternity. Gaudí's famed individualism and his artistic vision mediated his contact with ideas. Firstly, he took his personal devotion very seriously, especially on reaching middle age. In 1894, during Lent, he subjected himself to a complete fast and was confined to bed. By then his fame as an architect was such that the local newspapers carried reports of his progress. In addition, accounts suggest that his conservative views could also be critical and his personal austerity, combined with his benevolent concern for the poor, prompted a critical stance of the Church.

Casa Milà

Chimney pipes on the roof, detail

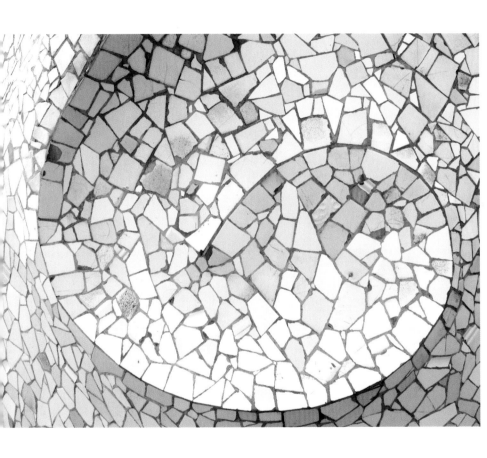

Thus Gaudí's own independent thought serves to remind us that it was in his workshop with his architects and craftsmen that he designed, forged and carved his response to theology as well as to the nationalistic concerns of Catalan culture. One way to measure Gaudí's public recognition is the response to his death. He was killed as a result of an accident. On Monday 7 June 1726, after a day's work in the workshop of the Sagrada Familia, he set off on foot, as was his custom, across the city to the Church of San Felipe Neri to attend confession. He was never to arrive. In the inquiry into his death the driver of a tram reported that he had hit a man who appeared to be a tramp, and that he had been unable to slow down.

Casa Milà

Detail of chimney

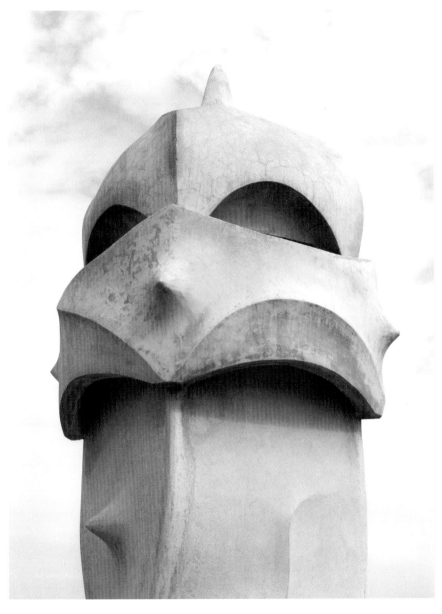

119

The tramp-like figure was none other than Gaudí! After the accident he was assisted by two passers-by and the Guardia Civil, who eventually took him to a nearby dispensary after being refused assistance from several taxi drivers due to the appearance of the victim. As a result of being knocked over by the tram Gaudí suffered fractured ribs, cerebral contusions and haemorrhaging in his ear. He was taken to hospital, yet he remained unidentified. The failure to identify Gaudí may be explained by the fact that his personal austerity had become such that he rarely changed his clothes, which were recognisable to his peers.

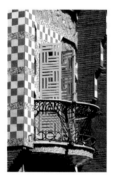

Casa Vicens

View of façade from Calle de Carolines

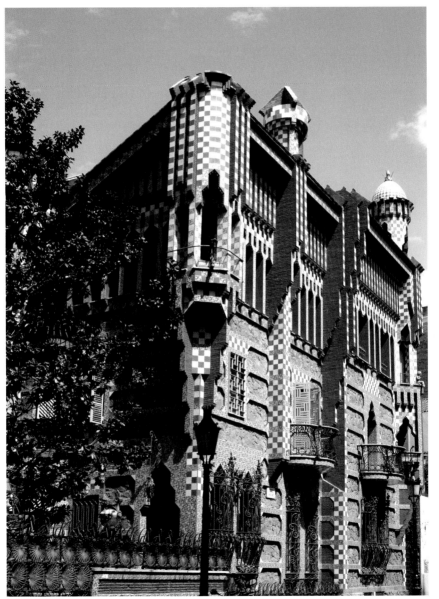

Although his appearance and clothes had been the subject of caricatures in the press, when seen in the grave context of a hospital and not set against the backdrop of the Sagrada Familia, his image rendered him anonymous. However, Gaudí had not been forgotten. His friend Mossèn Gil Parés became concerned by his absence and that evening began looking for the architect in Barcelona's hospitals. He was found in the Santa Cruz hospital. After he was recognised he was moved to a private room and the following day he regained consciousness. The news spread and Gaudí was visited by friends, official representatives of Church and State and others who wanted to show their respect for the architect.

Casa Vicens

Tower detail

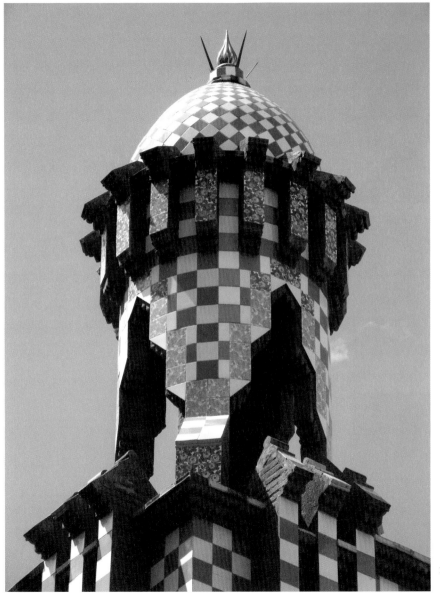

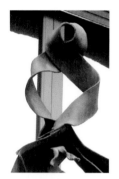

As well as these displays of recognition for the man and his work, Gaudí's final days were also a display of his faith and political sentiments. He was given the sacrament of the Last Rites, and as he lay in bed awaiting death he held a crucifix. He had been offered a private clinic, rather than the public hospital, however he insisted that he remain and end his life amongst the people. Gaudí died on Thursday 10 June. His passing was marked by a funeral that honoured his contribution to the traditions and faith of the Catalan people. Papal permission was acquired to bury him in the crypt of the Sagrada Familia, and the funeral took place on the Saturday.

Casa Milà

Façade from Calla Provença, balcony detail

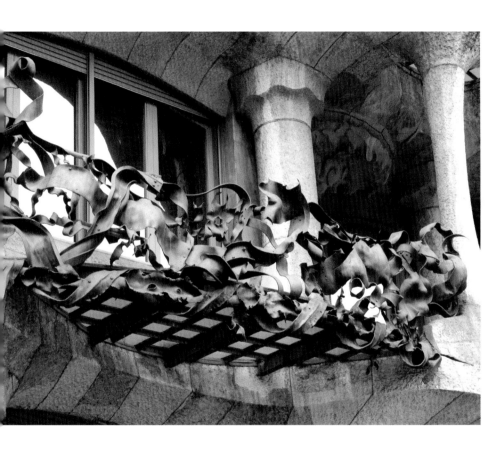

The procession that followed his coffin to its final resting place testified to the architect's importance and recognition among the different areas of society: it included politicians from Barcelona as well as his native town of Reus; representatives of the Church; members of the religious and cultural associations he had belonged and contributed to, and many of the craftsmen from the city-workers' guilds also attended. In this way the passion and commitment that Gaudí had shown in the different aspects of his life and work were all commemorated.

Casa Vicens

Tower detail

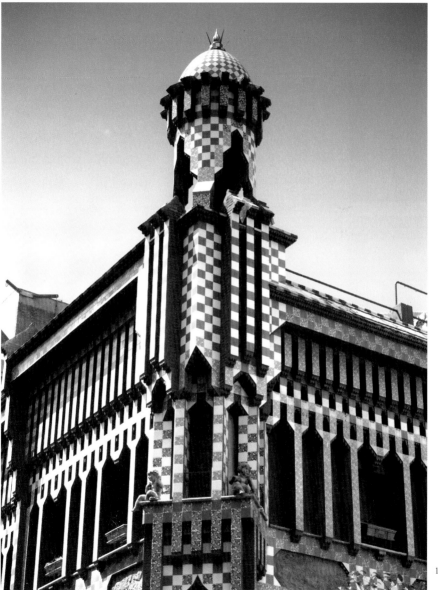

Gaudí's Barcelona

Gaudí's support for Catalan nationalism combined with his dedication to the Catholic faith, were important social and cultural factors that informed his work as an architect. These aspects of Gaudí's work can be examined in more detail, through an analysis of the development of a modern discourse and practice of architecture in Barcelona. Integral to these developments was Barcelona's national and spiritual identity. Both had evolved over the course of long histories spanning centuries, however in the nineteenth-century they were given renewed vigour and what is more became closely linked.

Casa Vicens

Lateral façade

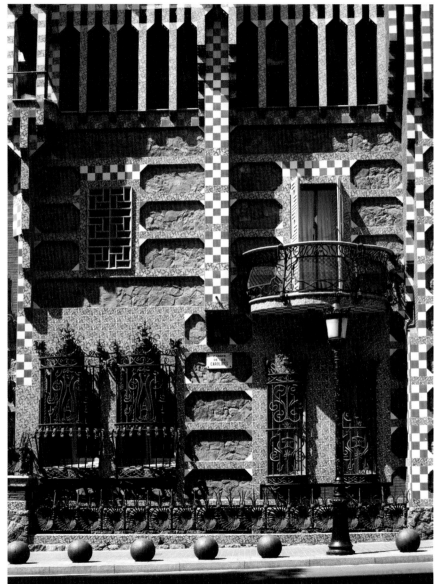

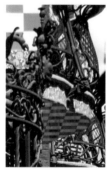

At the heart of this cultural change was the growing industrial strength and economic wealth of Barcelona and Catalonia as a whole. Architecture provided a key medium for individuals and the city to define a modern identity and express the new found optimism the modern era promised. This section locates Gaudí and his work amidst his contemporaries, and seeks to view him less as an isolated genius, and more as a man of his times whose work sought to embody many of the ideals of Barcelona as an historical, spiritual and modern city. The following discussion combines discussion of historical and theoretical themes with an analysis of a series of works by Gaudí.

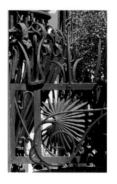

Casa Vicens

View of façade with window detail

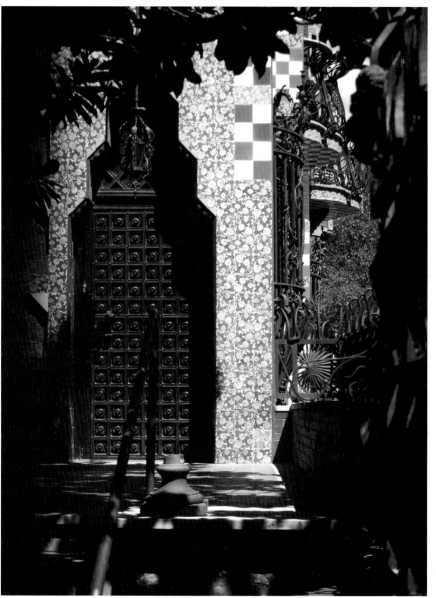

Some of these are designs on paper and were never built or are now lost, while others are completed buildings. The intention is to provide a general introduction to Gaudí and Barcelona as the nineteenth-century merged into the twentieth, however it is also centred around the statement of Basegoda i Nonnell that, "When discussing Gaudí one cannot distinguish the concepts of architect, interior decorator, designer, painter or artisan. He was all of these things at the same time."

The works examined illustrate the diversity of Gaudí's skills, and although many of them could be called minor works they all offer fascinating insights into his design, art and architecture.

Casa Vicens

Detail of iron grille entrance

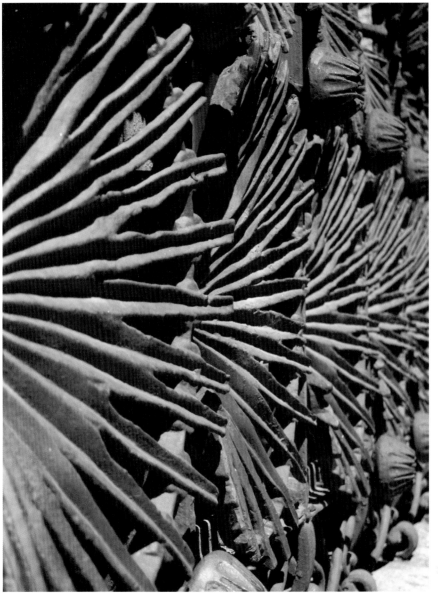

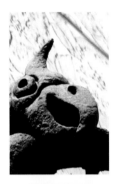

Gaudí may be identified with a number of artistic and intellectual currents running through Western Europe as industrialisation brought rapid change to almost all aspects of life. The Arts and Crafts Movement and the style known as Art Nouveau are the clearest parallels. However, to map these webs of connections frequently offers a vision of the past configured more by contemporary interests. The approach taken here is to focus on the specific cultural setting of Barcelona, and in particular the movement known as *Modernisme*, which should be translated as Modernism with caution if at all, as it refers to a very specific period from around 1890 to 1910. *Modernisme* is applied to a range of visual and literary arts.

Casa Vicens

Window with moulded iron dragon

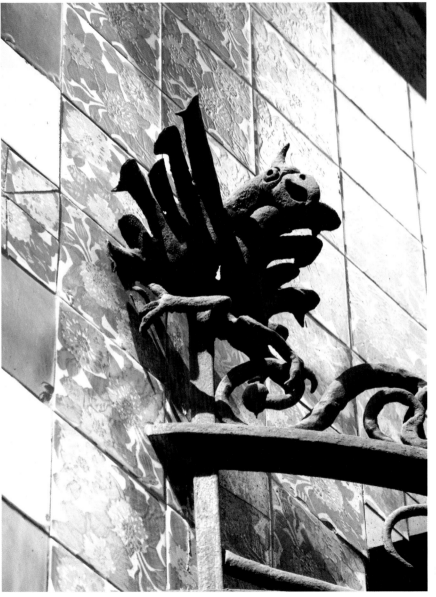

With regard to architecture the term describes a group of architects led by Gaudí and Domènech i Montaner but also including other names such as Josep Marià Jujol, who worked closely with Gaudí. Where modern cultural movements begin and end is always a point of debate. Some historians would place the start of *Modernisme* between 1883 and 1888 with Gaudí's *Casa Vicens* while others not until Domènech's work for Barcelona's Universal Exhibition in 1888. Consensus seems to have been reached that *Modernisme* as an architectural movement had run its course by 1910, which raises the issue of where to place Gaudí's last works such as the Sagrada Familia.

Casa Vicens

Window with moulded iron dragon

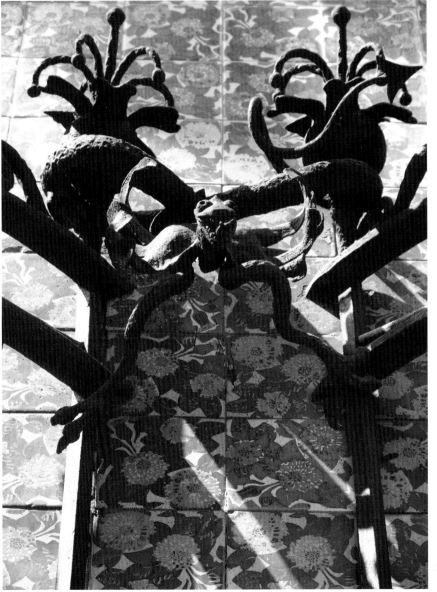

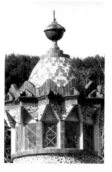

Robert Hughes states:

"In certain respects Gaudí was not a *modernista* architect at all. His religious obsessions, for instance, separate him from the generally secular character of *Modernisme*. Gaudí did not believe in Modernity. He wanted to find radically new ways of being radically old..."

However, Gaudí may undoubtedly be identified as making a key contribution to Barcelona's *Modernisme*. To explore his identity as a 'modern figure' the concerns of *Modernisme* need to be considered in more detail.

Finca Güell

View of building

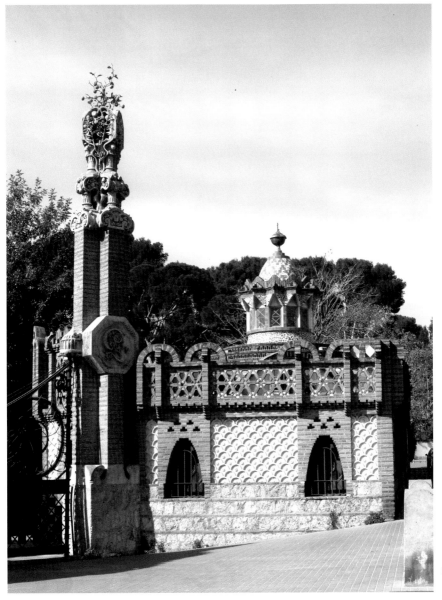

Attention will be focused firstly on the needs of the city, then on theories of architectural style and finally on the ideological dimensions of architecture. The history of nineteenth-century architecture in Barcelona is marked by a need to respond to the growth of the city. The rapid growth of population produced by industrial factories led to urban expansion beyond Barcelona's famed medieval quarter with its winding Gothic streets. In 1859 the City Council held a competition for designs for a new urban plan. It was won by the engineer Ildefons Cerdà, who presented an abstract rational design of straight streets divided into equal blocks of living space, named the *Eixample*.

Finca Güell

Cupola on the Riding school

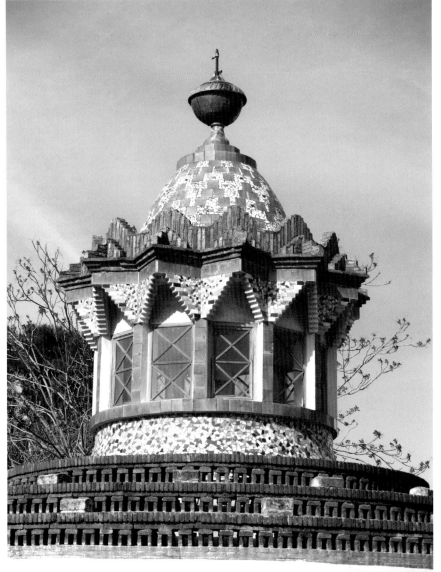

141

At its heart were two diagonal avenues which intersected with a third horizontal one to create what is known today as the Plaça de las Glories Catalanes. In 1860 the first stone was laid by Queen Isabella II and Barcelona's appearance as a modern city was decided. Subsequent generations were critical of the design, for the lack of variety that it imposed on the city. To maintain a focus on Gaudí it is not possible to consider in detail the merits or defects of Cerdà's plan; in any case it has subsequently been distorted by developers. Cerdà's plan had intended to integrate into the city important architectural features and social amenities to make urban life bearable,

Finca Güell

Detail of entrance gate column

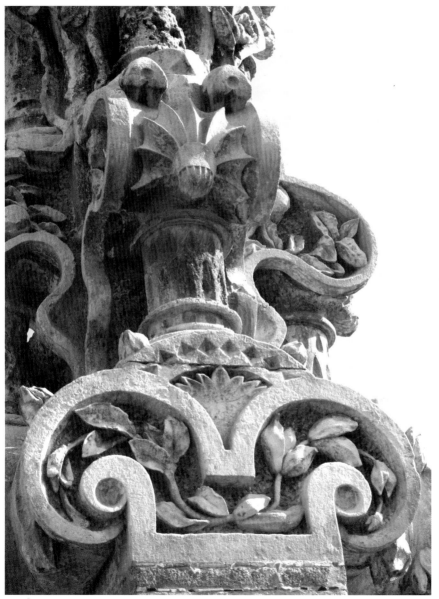

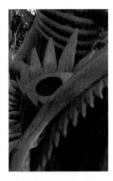

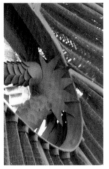

such as patio gardens at the heart of each block of apartments, centres for medical care and food markets. Cerdà's design was based in part on research of the existing living space of the city, and responded to the poverty that he saw. While subsequent generations sought more imaginative solutions to the problem of urban space the design brief they were faced with was similar: to solve the social problems raised by changes to urban life. Furthermore, Cerdà's *Eixample* established a standard type of townhouse with a façade facing the street, another looking onto a courtyard at the rear, and with load bearing walls built around patios that provided ventilation.

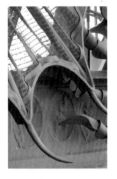

Finca Güell

Ladon, the guardian of the Gardens
of the Hesperides (dragon detail)

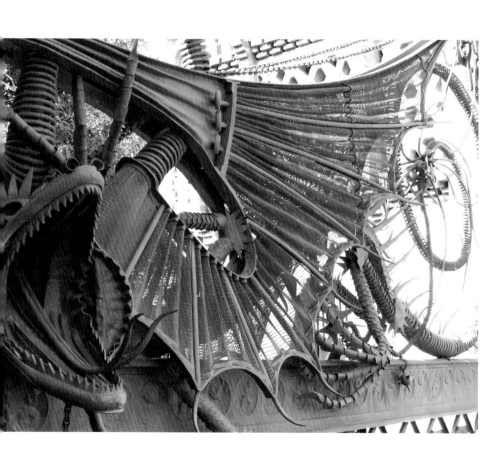

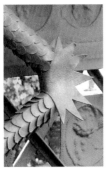

The *Casa Battló* and *Casa Milà* are Gaudí's contribution to Cerdà's plan and each are based on the type of house established by the *Eixample*. Projects such as the Park Güell were also inspired by the aim to improve urban life, but in a less abstract way. Finally, the scope of Cerdà's plan is a representative example of the new spirit that animated the minds of Barcelona's architects and patrons. While Gaudí and his contemporaries, the generation of *Modernisme*, thought very differently from Cerdà they all shared the confidence and vision to plan on a bold and grand scale. Cerdà's plans for the city were underpinned by his belief that, "…we lead a new way of life, functioning in a new way. Old cities are no more than an obstacle."

Finca Güell

Ladon, the guardian of the Gardens
of the Hesperides (dragon detail)

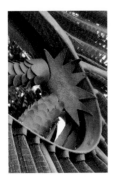

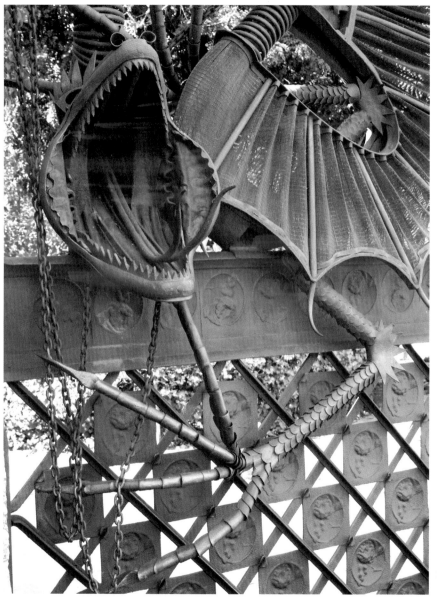

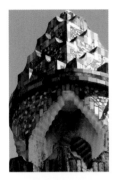

Considered in the context of nineteenth-century architecture his statement signals the distinction between an engineer and an architect. For the architectural community the buildings of old cities, towns, and even ruins were an important source of inspiration for architectural style, which is a second factor informing *Modernisme*. Two currents of thought animated responses to the history of architecture: firstly, international developments in architectural theory and practice, and secondly, the development of a modern Catalan architecture. Both of these formed an important foundation for Gaudí's development as an architect.

Finca Güell

Entrance gate detail

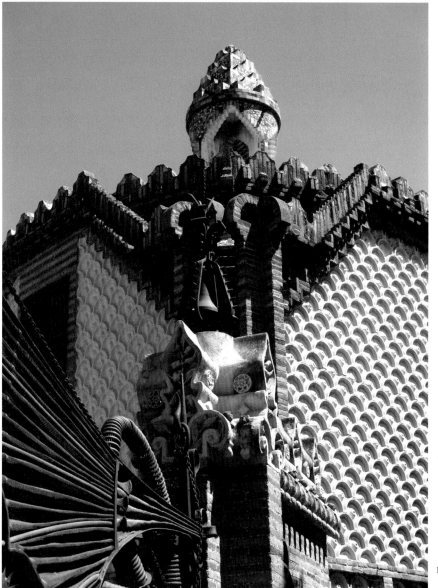

The generation of his university teachers had been important in initiating this process. Elias Rogent i Amar was an architect whose work comprised both these elements. Unlike Gaudí, Rogent had travelled widely in Europe. In addition to this he had studied the works of the French theorist Viollet-le-Duc, who is known for his important analysis of Gothic architecture, which concentrated not on its aesthetic appeal, but instead on the structural elements at its core. The academic study of style in this French theorist's work provided a foundation for an increasingly eclectic use of architectural styles and decorative motifs.

Finca Güell

———————

Decorative relief on the wall

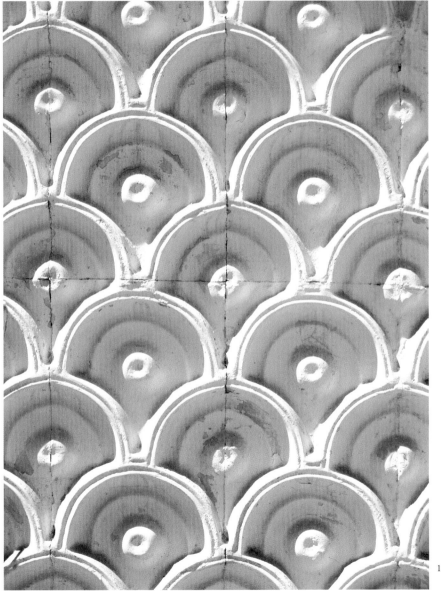

In Barcelona this eclecticism was frequently based on the use of regional Catalan styles, and often supplemented with other national Spanish styles such as the Moorish style.

An example of this gradual eclecticism in Rogent's work is found in the first major building added to Cerdà's *Eixample*. In 1872, after twelve years of work, the new University of Barcelona was opened. On approaching the building there is little about the Romanesque style that declares itself as modern. However, no building from the Romanesque period exists on such a scale.

Finca Güell

Wall tile detail

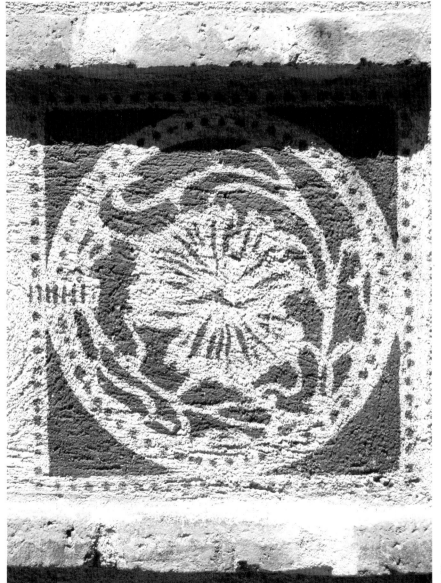

153

The sober and ordered style places an emphasis on the horizontal plane created through the repetition of the arches on each storey. The rhythm created by the arches creates a harmonious effect and animates the imposing bare wall. The building evokes the form of a monastery: during the medieval period the monastic orders had made fundamental contributions to the establishment and the development of European Universities. The choice of style is also concerned with origins. Catalonia is especially rich in Romanesque architecture and Rogent's choice was guided by an interest in employing a national style.

Finca Güell

Antinomy orange tree

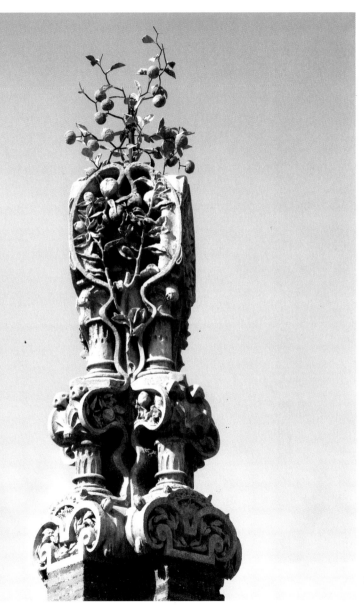

The nationalistic tendency in architectural practice would become well established, through the work of figures such as Rogent, by the time Gaudí began his studies. However, it should be noted that the historical approach to style did not dictate the whole building: the interior decoration of Rogent's university building combines Islamic and Byzantine elements, and these clearly demonstrate eclecticism at work. Rogent's work and the ideas it upheld were a stage towards a more impassioned engagement with the modern and national significance of architecture, which the next generation took on.

Finca Güell

Cupola on the porter's lodge pavilion

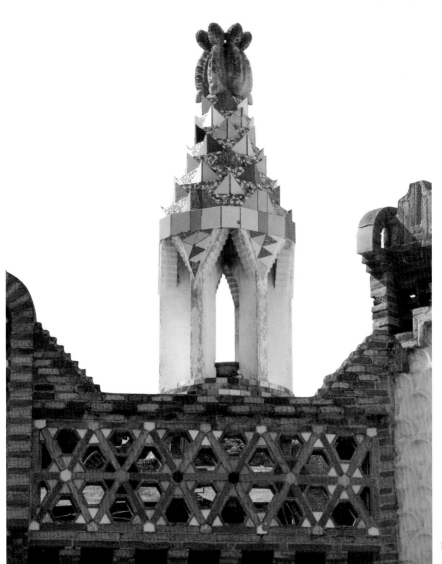

In 1878, the year Gaudí qualified as an architect, a contemporary, Lluís Domènech i Montaner, published his essay *'In search of a national architecture'*. Although a brief treatise, Domènech's essay provided an overview of the history of architectural style. Underpinning his analysis were the ideas of a second architectural theorist, Gottfried Semper, who in his writings had identified key structural elements fundamental to architecture and argued that style was dictated by social circumstances. The lesson Domènech advocated was on the one hand the positive contribution of modern materials,

Finca Güell

Entrance gate column detail

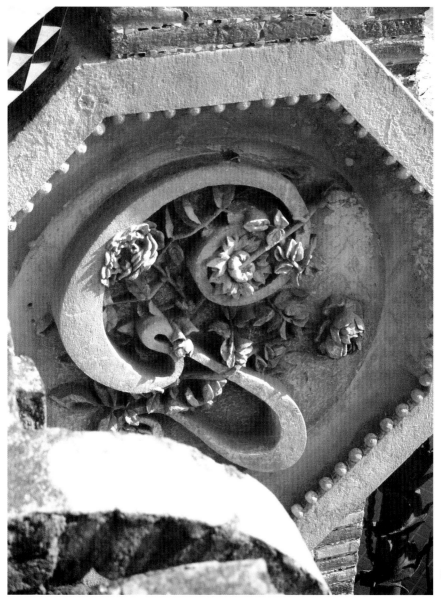

159

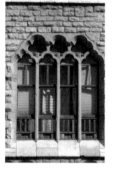

and on the other a new approach to the lessons that could be learnt from history. For Domènech the two ideas were inextricably linked, new materials provided new structural possibilities which in turn signified that the architecture of the past should not be slavishly imitated, but rather applied to the new forms of architecture. Domènech's thesis marked a move away from the ideas of Rogent's generation, who adhered to an academic authenticity in their borrowings from the past, and Domènech initiated a new, bolder phase of eclecticism.

Casa Botines

General view

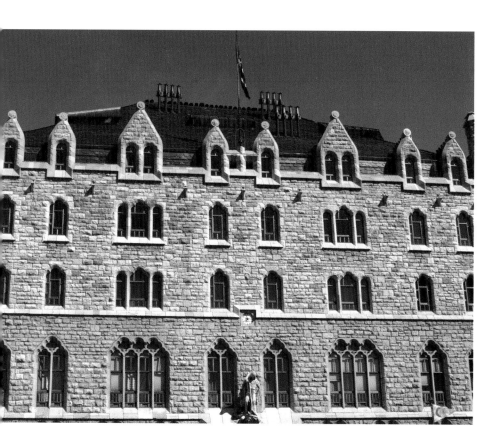

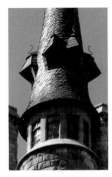

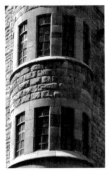

Domènech fully recommended the study of all the history of architecture, "the practice of all good doctrines" but his aim was to, "... apply the forms that new experiences and needs impose on us, enriching them and giving them expressive strength," and he proudly declared himself guilty of eclecticism. Gaudí would embrace his arguments, and the results bore impressive results in the houses he built, but in the last decades of his life he gradually developed his particular, mature style, which the architectural historian Mireia Freixa terms "the impossible confluence between abstraction and expression".

Casa Botines

Corner view of building

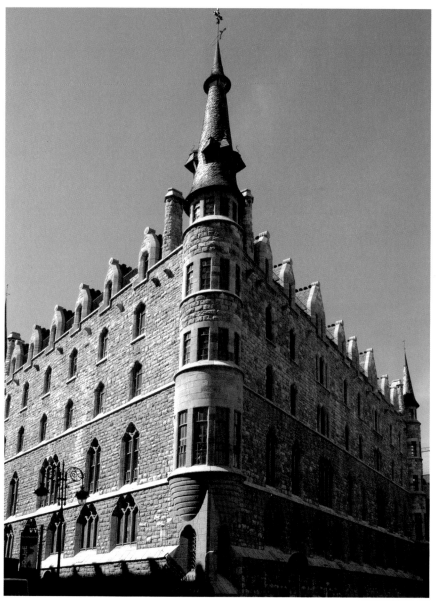

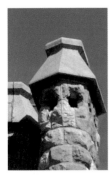

One of a number of Gaudí's statements, recorded by his disciples, illustrates his relationship to the ideas of Domènech, although when he said it is less certain:

"The aesthetic structure is that which explains the construction with its various resources and resolution of fecund problems, making pleasing objects for themselves... The first quality an object has to have in order to be beautiful is to achieve the aim for which it was intended... In order that an object be beautiful in the highest sense it is necessary that its form has no superfluous detail, but that which is rendered useful to the material conditions."

Casa Botines

View of tower

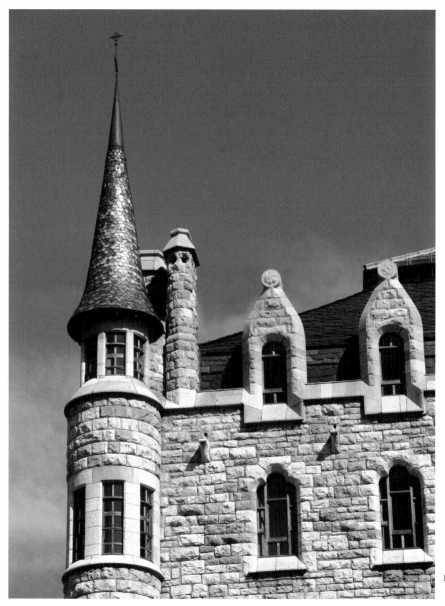

Framed by the terms structure and beauty Gaudí offers his own theoretical insight into the themes raised by Domènech. Another comment ascribed to Gaudí clearly links him to eclecticism.

"Originality is to return to the origin."

However, Gaudí's buildings often combined a number of origins and elements from Gothic, Romanesque and Moorish architecture. They are significant as they signal Domènech's identification of these styles as Spain's three national styles. The two architects even worked together on a new design for the façade of Barcelona Cathedral,

Casa Botines

––––––––––

Saint George

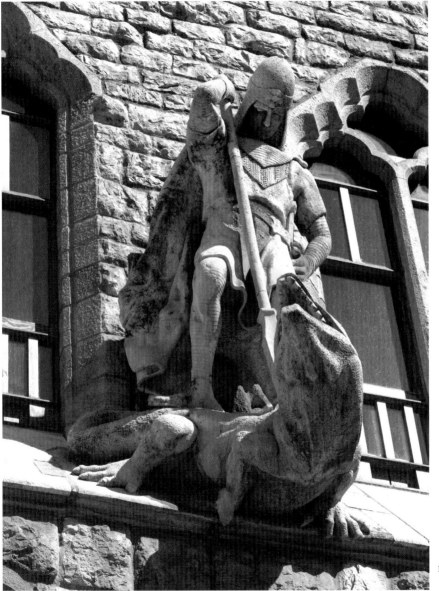

167

which reveals their commitment to the development of a specific Catalan tradition. The ideological dimensions of their thinking provided an important dynamic in the development of their architectural work.

Mireia Freixa has written that, "The recovery of Catalan Culture is the task that unified the majority of Catalan artists and intellectuals in the broad period that runs from the *Renaixença to Noucentismo*. The *Modernista* generation simply substituted the romantic nostalgia for the decisive will to modernise the country..."

Park Güell

Gate house

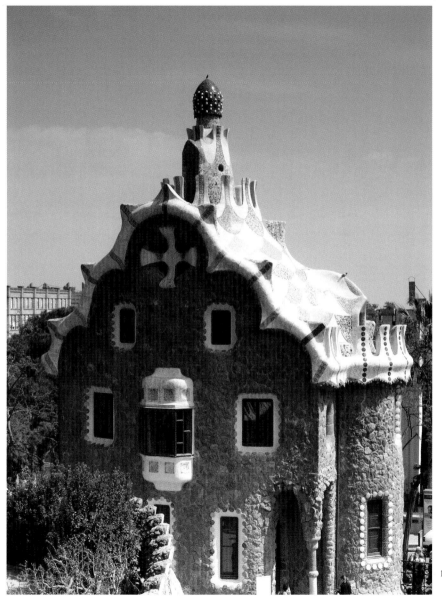

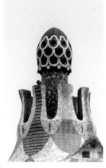

Freixa introduces two new terms, the *Renaixença* and *Noucentismo*, in addition to *Modernisme*. The second term is less relevant to the discussion of this chapter as it refers to the shift in interests from the more extravagant *Modernisme* to an austere classicism in the early twentieth-century. However, the *Renaixença* is important. The term, which may be translated literally as 'the Renaissance', encompasses concerns to advance and protect the economic growth of Barcelona and Catalonia as well as to nourish the region's literary and artistic traditions.

Park Güell

Services pavilion

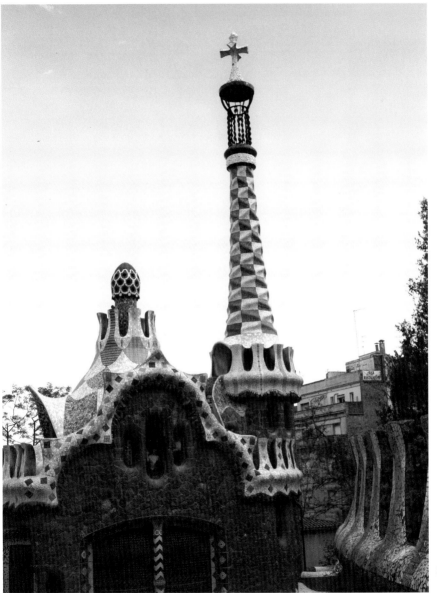

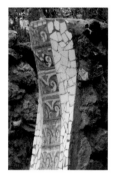

Until the nineteenth century the economic and mercantile history of Barcelona has been a period of wealth and international recognition followed by decline. During the course of the nineteenth century Catalonia, and Barcelona especially, witnessed a dramatic economic recovery as a centre for a range of industries and textiles, and from the wealth and confidence that resulted, the *Renaixença* was born. In terms of the economic aspects of this wealth, Gaudí himself made a contribution to the history of factory design in his work for Spain's first workers' cooperative, known as the Mataró Cooperative.

Park Güell

Mosaïc detail

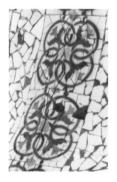

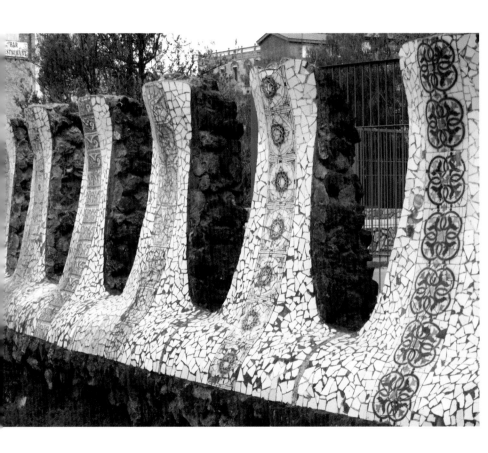

Inspired by the development of Socialist and Anarchist political and economic thought, it was run by workers to make cotton goods, and combined industrial production with education and social activities for the workers. Gaudí was a friend of one of its organisers, Salvador Pagés. In 1878 Gaudí produced a number of designs for the Cooperative which included making a plan of all the installations and facilities. The most important works built were the bleaching room for cotton and two residential houses for thirty workers.

Park Güell

Trencadís mosaïc of the bench

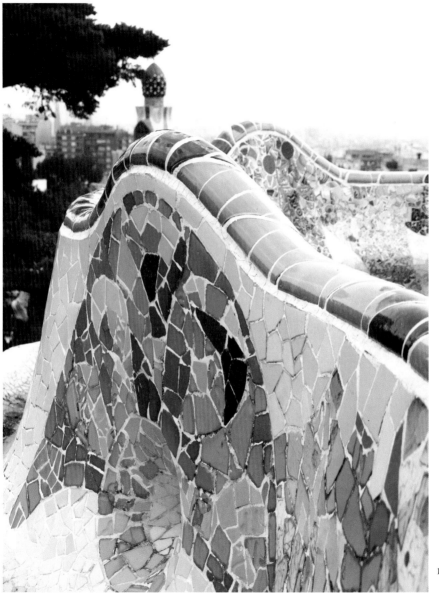

The bleaching room, although a simple building with a wooden frame and brick structure, is perhaps the most important aspect of this project as Gaudí used what is known as a cantenary arch as framework for his structure. The advantage of this particular type of arch, which he made out of short pieces of wood joined together to be economical, is that it allowed him to span the wide space of the bleaching room with a taller roof. The cantenary arch would become a key element in Gaudí's architecture and would enable him to create some remarkable architectural spaces. Thus this simple work is the first step in the evolution of his style.

Park Güell

Mosaïc medallion

Apart from a rather uninformative design, nothing of the workers' residence exists, but there is a more elaborate design for the cooperative's main building, known as the casino. While the right-hand image showing the street façade with its eclectic use of Classical and Romanesque styles presents a more sober image, the image on the left garden façade reveals an elaborate look. The spiral staircase indicates Gaudí's awareness of Islamic traditions and materials. Together these designs for a worker's cooperative are testament to the confidence then reigning in Barcelona.

Park Güell

Mosaïc medallion

179

Another facet of Gaudí's work is revealed by a poster he designed for the cooperative. The text's capital letters recall those found in medieval script. The imagery combines nature and industry with the cooperative's symbol, the bee, referring to the insect's dedication to the community and work, the loom from which plants bloom illustrates the latter activity.

Gaudí's ability to address the practical needs and express the aspiration of the cooperative through his work should not be interpreted as an indication of Gaudí's own political position. Even though he did contribute painted slogans to the assembly hall such as:

Park Güell

Fountain

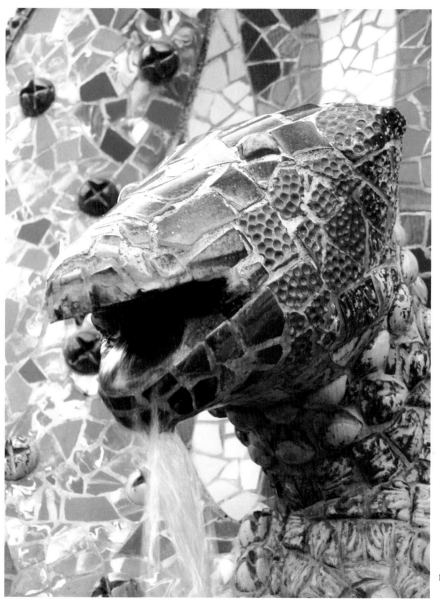

"Nothing is more powerful than brotherhood"; "Comrade show solidarity, practice goodness"; "Much formality shows a wrong upbringing"

Before too long, the anarcho-syndicalist tone of these slogans would seem a radical statement by Gaudí as this was only a brief foray into the world of the modern worker for him and his subsequent work was for the employers of workers. One reason for this was the need for money. After the project he stated that there would be no more of such work, arguing, "As you know only too well, I live off my work and I cannot commit myself to vague or experimental projects..."

Park Güell

Salamander covered with ceramic mosaïc in trencadís

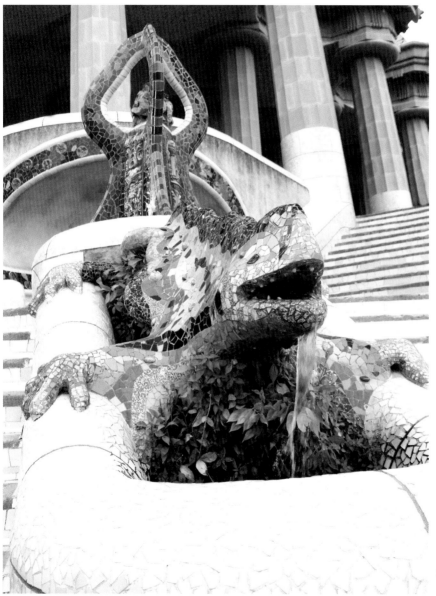

Thus the designs for the Mataró workers should be read as a young architect responding to opportunities to launch his career. However, Gaudí's aspirations to design more complex buildings with better budgets, as well as rewards, would allow him to explore the stylistic possibilities of Modernisme with its eclectic approach, and this would have also influenced his decision to seek other clients.

Before turning to examine the ideas Gaudí allied himself with as an established architect there are two other examples of him working on practical projects at a later point in his career. The first work is the workshop he designed for Josep and Luis Badia, built in 1904.

Park Güell

Columns

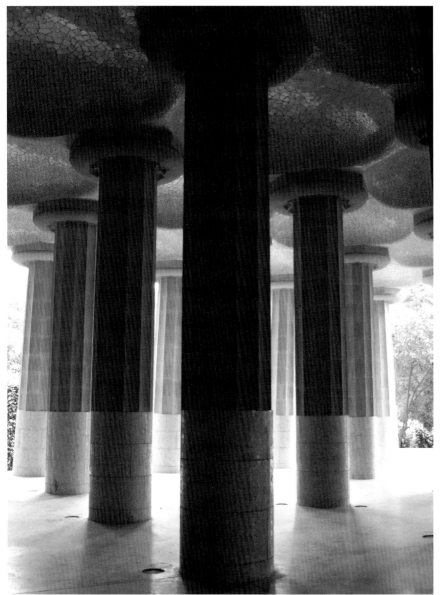

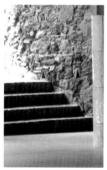

The Badias were craftsmen who worked in wrought iron and collaborated with Gaudí on a number of commissions. It is thought that they paid for the design in part through their labour. The design is simple but distinctive. It marks Gaudí moving to develop his own way of working with curved forms. However, it also reveals his ability to produce simple designs using economically viable materials such as brick, stone and tiles. What is more these materials give a sense of solidity and permanence. The second project is a bridge he designed for Pomaret between 1904 and 1906, (Collins, Plate 45B).

Park Güell

Columns

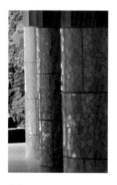

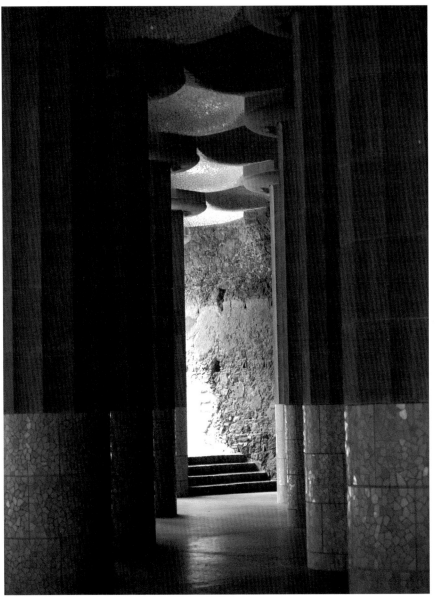

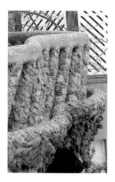

Although the project never extended beyond the design stage it reveals Gaudí developing a project that combines practical function with the aesthetic forms created by the alternating piers of the bridge's arches and the undulating form of the barrier. Furthermore, he added a short prayer to St Eulalia. It is thought coloured mosaics would have been used for the writing of this. For an indication of what forms and colours this bridge may have taken the images of Park Güell offer some ideas. It is interesting to note that the Park Güell also combined a number of religious motifs which signal Gaudí's identification with the conservative branch of *Renaixença* thought,

Park Güell

Leaning columns of the viaducts (balcony)

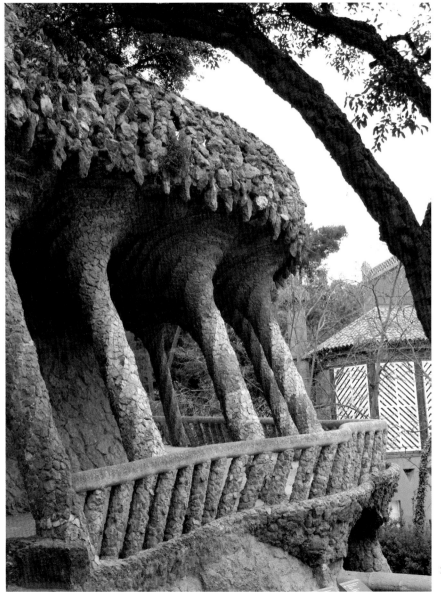

189

with its emphasis on religious tradition and morality. An impressive intellectual and cultural vitality accompanied the economic growth in Barcelona. Domènech's treatise is one good example of this, with its concern to link architecture with the national identity of Catalonia. Gaudí himself wrote a review of an industrial exhibition for a newspaper entitled the *La Renaixença*. A quotation from Dr. Torras y Bages, a high ranking ecclesiastic Gaudí knew well and for whom he would later design a funerary monument, illustrates this ideological current:

Park Güell

Leaning columns of the viaducts

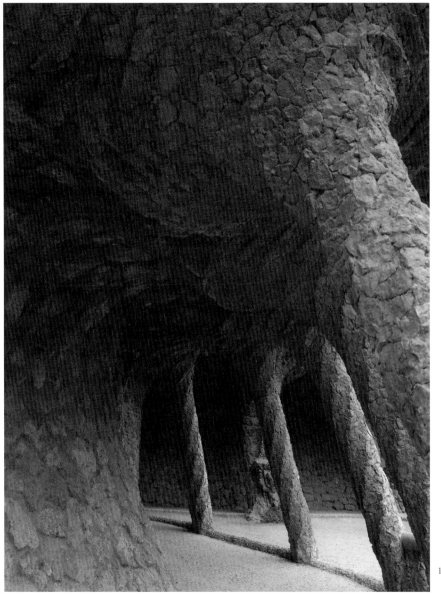

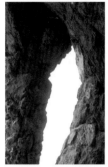

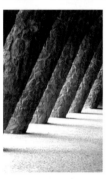

"You that work for the restoration of our life, skilled lovers of Catalonia, that work for the region, you work also for the restoration of human sentiments, in order that you achieve a truly human literature... he who loves mankind, has to love mankind in his land, like a saint is venerated at its altar."

This statement was given at a literary competition. These were regular events aimed at generating and promoting Catalan culture. The specific audience of Torres y Bages was the Catalan section of the Catholic youth of Barcelona and it is a good example of the religious brand of the *Renaixença* spirit.

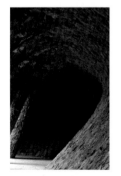

Park Güell

―――――――

Leaning columns of the viaducts

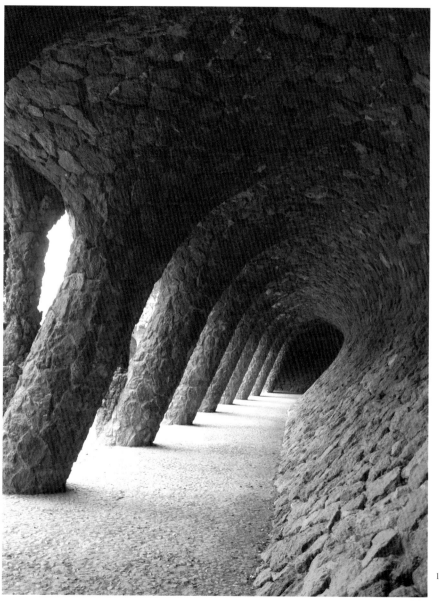

Conservative positions such as these contrasted with the more objective position of Domènech and other more radical lines. While Picasso lived in the city before moving to Paris he identified himself with a group of artists, including Santiago Rusinyol and Ramón Casas, who met in the famed *Le Quatre Gats* cafe. Gaudí had nothing to do with the more decadent and anarchic cultural activities of these gatherings. He thought along more conservative lines and sided with the establishment as represented by churchmen like Torres y Bages or his other wealthy patrons.

Park Güell

Leaning columns of the viaducts

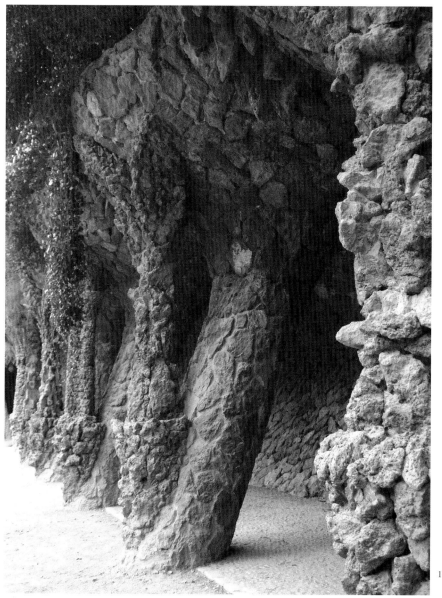

The building of the Sagrada Familia, which spans the period of *Modernisme* and beyond, is Gaudí's grandest expression of the conservative aims of the *Renaixença*. However, his many domestic projects also mark important contributions as expressions of the more luxuriant taste and optimism of Barcelona's bourgeoisie. Two public monuments Gaudí built provide an insight into those elements of Barcelona's *Renaixença* society that he identified with. Firstly there are his designs for a parade in honour of Francisco Vicente García, known as the Rector de Vallfogona. The rector had been a seventeenth-century cleric famed for his poetry.

Park Güell
—————

Column effect in the park

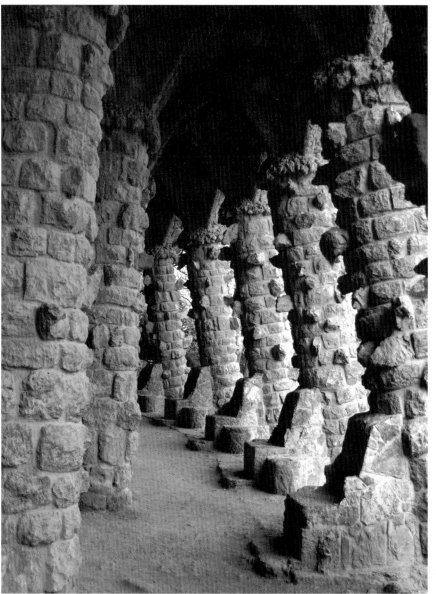

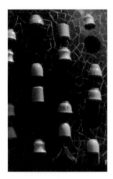

In his own lifetime he counted the prolific playwright Lope de Vega as a friend, which is an endorsement of his literary ability. For the two hundred and fiftieth anniversary of his death the town of Vallfogona decided to arrange a series of celebrations, part of which included some elaborate processions whose ornamental carriages were designed by Gaudí. Unfortunately, the Gaudiesque procession never took place. However, the existing drawings reveal how he planned for an appropriate renaissance-style procession dedicated to pastoral themes of the harvest of the cornfields, the vineyards and the olive groves.

Park Güell

Gate house with tower

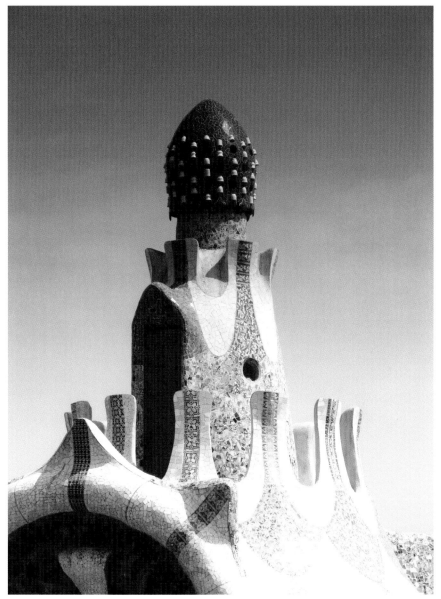

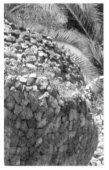

The characters are shown bearing torches and the Donkeys and carts are decorated with garlands of flowers. Gaudí has sought to conjure up a poetic recreation of an early modern procession that includes music and ceremony. An important aspect of this commission is that it may well have resulted from connections he made through the associations of 'excursionistas'. In any case it is certain that such activities would have fired his imagination to create these designs. Although uncertain, it is thought Gaudí also may have contributed to a permanent and explicitly political monument dedicated to Dr. Robert, who was mayor of Barcelona in 1899.

Park Güell

Columns in the park

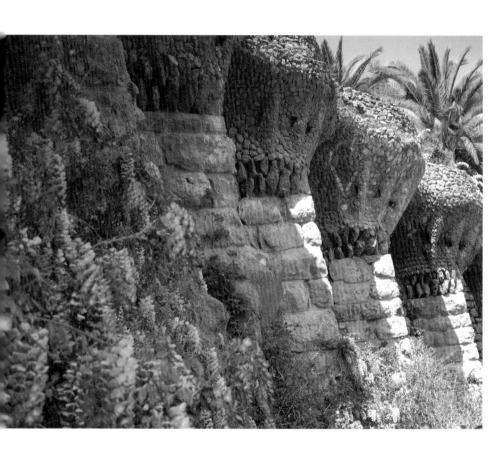

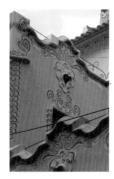

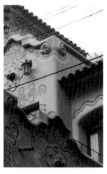

During his brief period of office he took a bold stand against government demands from Madrid, which was seen by some as a centralising force trying to dominate the concerns and prosperity of Barcelona. Such was his intransigence against Madrid that war was declared on Catalonia, but was avoided by Dr. Robert's resignation and submission to the government demands. In 1907 a monument was set up to the ex-mayor who had died in 1902. Gaudí's contribution to it is considered by some to be the base, which is a monumental, geological form, evoking the mountains of Catalonia, which play an important role in the region's national identity.

Park Güell

Casa Gaudi

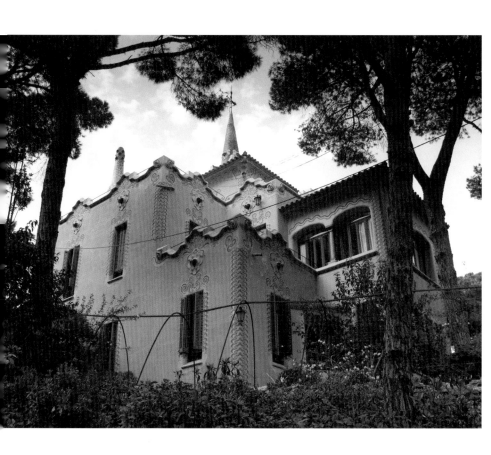

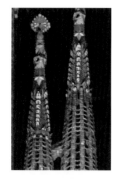

The style of this design is one of the principal arguments for claiming the work to be Gaudí's. At the monument's sides there are short cave-like passageways, and from this mountain, symbolising the strength of Catalonia, flows water from fountains. Above are a series of allegorical figures, including Dr. Robert and Truth. These were sculpted by Juan Llimona Bruguera. Under the dictatorship of Franco the sculpture was dismantled because of its radical message, but was replaced in the 1980s. Both Gaudí and many of the patrons he worked for shared a selective view of modernity: they appreciated the advances in technology, such as automatic looms,

Temple of Sagrada Familia

Image of the old façade reflected in the park's lake

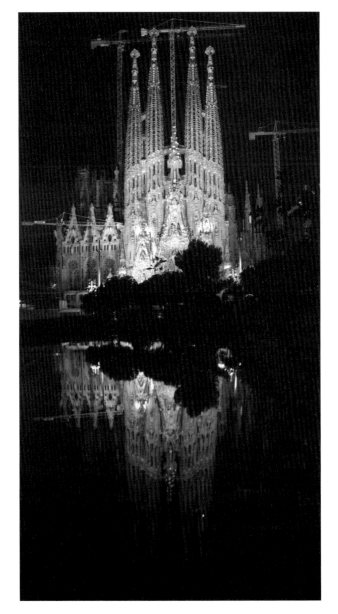

which increased their wealth, but were less convinced by changes in the social order, such as equal pay for women or even democracy. Gaudí stated, "Democracy is the rule of ignorance and stupidity."

He clearly moved away from any youthful association with the ideas of the Mataró Collective to a conservative view of the social order based on a rose-tinted, paternalist model of urban feudalism. Links may be noted between the appeal of the medieval styles of architecture and these social attitudes. A concern to sustain a rigid and ordered society, which is encountered across Europe, may be understood as an anxious response to the dramatic changes society was going through as well as concern to maximise wealth.

Temple of Sagrada Familia

View of the old façade as seen at night

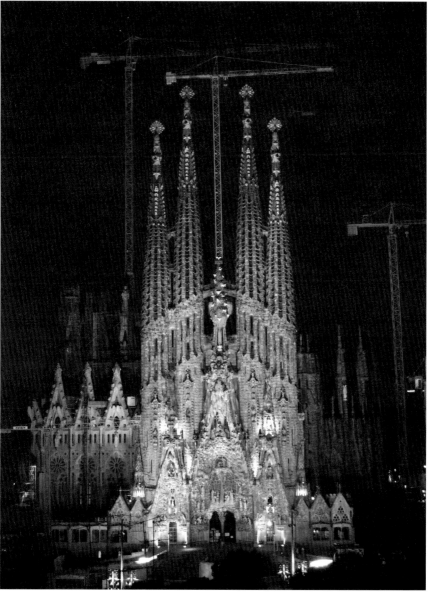

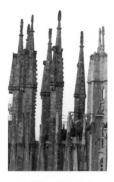

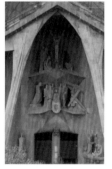

Gaudí himself preserved traditions in his way of working. He commanded a large workshop with assistants to carry out a range of tasks, such as carpentry, constructions in wrought iron, mosaic, painting and stained glass. By working in this way his connection to the ideals of the Arts and Crafts movement may be detected. An example of the range of work taken on by Gaudí's workshop and the quality of it is seen in the furniture he designed. The Marquis de Comillas, one of Gaudí's wealthiest patrons, commissioned a series of works for a private chapel. Gaudí designed a throne-like armchair, a *prieu-dieu* and a wooden pew.

Temple of Sagrada Familia

View of the new façade

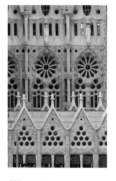

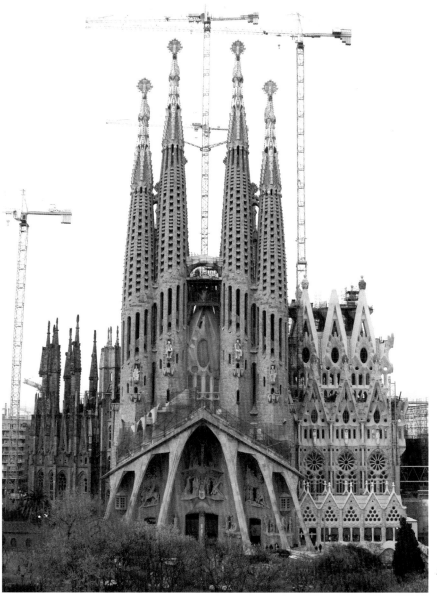

The latter reveals Gaudí's ability to work with architectural forms on a small scale and combine them with decorative carving. Seen from the side the carvings, which are supported on slender columns, incorporate Gothic pointed arches and an elegant sinuous winged dragon. The significance of the dragon is addressed later, when the country estate of Eusebio Güell is examined. Güell married into the Comillas family. For a number of the houses Gaudí built he also produced furniture, as was the case with the *Casa Calvet*, which was built between 1901 and 1902.

Temple of Sagrada Familia

Detail of the Nativity façade

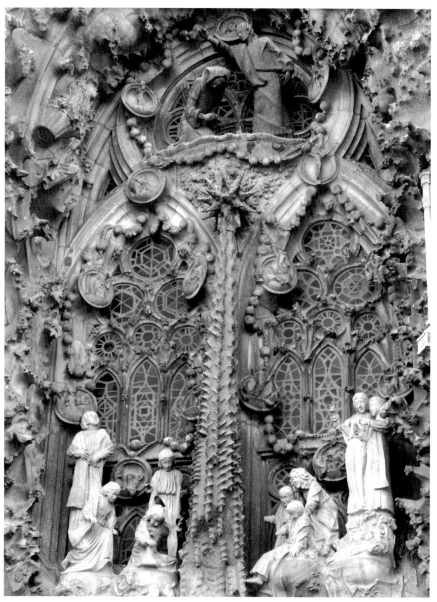

A preview of its elegant design is offered by the chairs Gaudí designed for the Calvet family. The designs reveal the development of the idea in Gaudí's mind as he experiments with various forms. By the beginning of the twentieth-century Gaudí had moved away from a clearly defined traditional style to a fluid and abstract design, which brings out the grain and colour of the wood. The contribution of Gaudí's assistants cannot be explored in great detail, even though some of their work makes highly original departures in the entwined histories of Art and Design and which mark their distinction from the Arts and Crafts movement.

Temple of Sagrada Familia

Details of architectural decoration forms

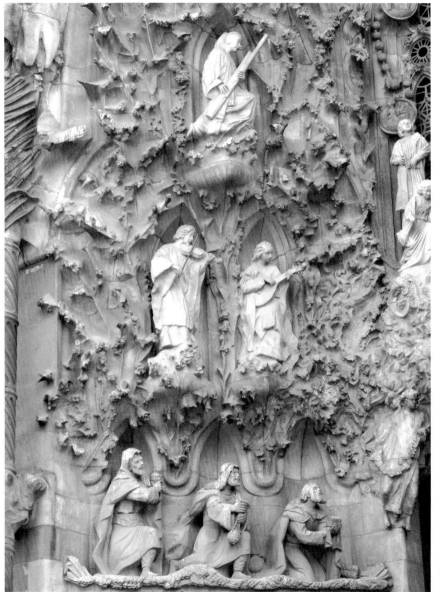

The role of the assistant does raise the question of authorship in Gaudí's work but it cannot be explored in detail here. However, it is clear Gaudí was the authoritative mind behind his work:

"The man in charge should never enter into discussions, because he loses authority by debate. ... The Architect is a governor in the highest sense of the word, which is that he does not find the constitution made, but makes it himself."

While this may seem authoritarian many of Gaudí's assistants worked with him all their life, and they were given the freedom to develop their skills and explore their imagination.

Temple of Sagrada Familia

Sculptures on the old façade

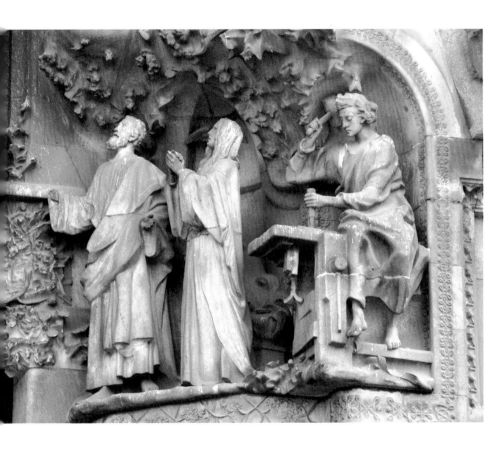

Thus Gaudí seems to have been a reasonable and enlightened 'governor'. Although Gaudí did use modern materials, through his team of assistants he promoted the use of traditional materials. One of the marked contrasts of the Sagrada Familia is the machine-worked modern section as opposed to the very different look of that which had been done by hand. The industrialised look diminishes the building's effect. The use of craftsmen allowed Gaudí to experiment with the effects of form and colour and to achieve 'the impossible confluence between abstraction and expression'.

Temple of Sagrada Familia

Nativity façade, detail of the caves with the three portals

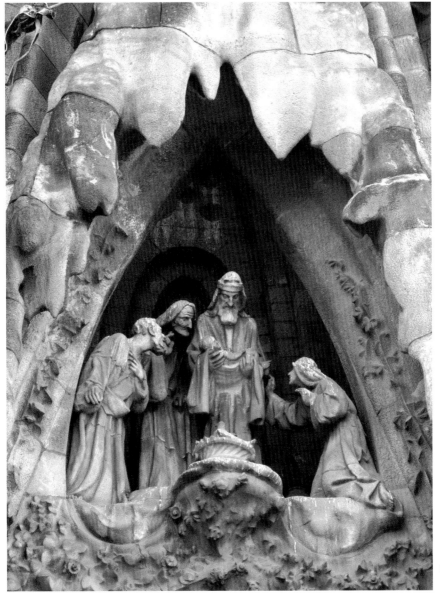

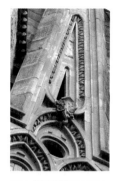

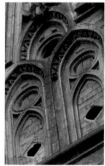

Gaudí explored this relationship of architectural form and significance with growing intensity. Besides the freedom of architectural styles provided by eclecticism and the range of media available to him from his assistants, a key factor in his designs was the study of nature. Nature is never far from his work, its organic forms and patterns provided a myriad of decorative features as well as examples of structural possibility. Furthermore, in Gaudí's neo-medieval outlook, nature was important evidence of divine activity:

Temple of Sagrada Familia

Side view

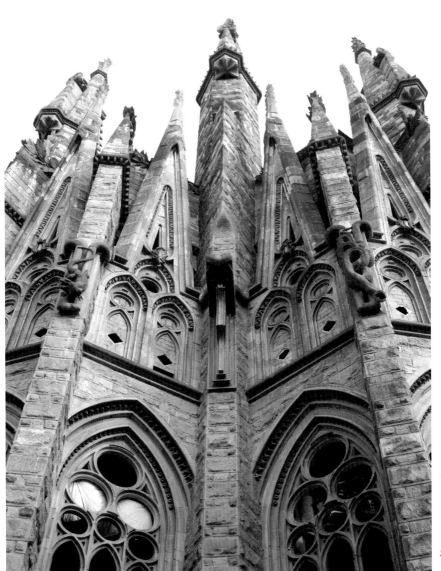

"God has not made any sterile law, that is to say, that all have their application; the observation of these laws and of their applications is the revelation of Divinity. Inventions are the imitations of those applications (a plane is an imitation of an insect; a submarine, of a fish). In this way when an invention is not in harmony with natural laws it is not viable."

Thus at the heart of Gaudí's work there is the concern to follow the laws of nature as they are the revelation of God. However the commitment to preserving tradition in all its forms was combined with a direct engagement with the modern world, and this dialectic is a subtle theme that is present in all of Gaudí's work.

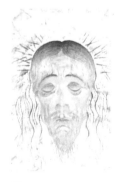

Temple of Sagrada Familia

The Veronica sculptures, of the Passion façade by J. M. Subirachs

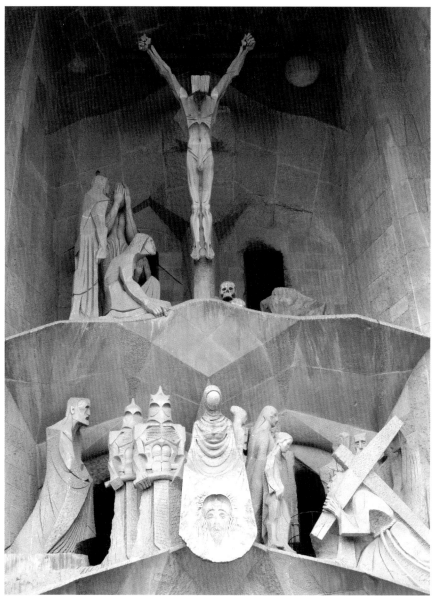

Despite looking back to the past with affection, neither Gaudí nor his patrons were isolated from the modern everyday world of Barcelona. Instead they were a new generation that sought to define the city and its urban spaces in new ways. Gaudí's large houses and apartment buildings were a principal means for him to do this. However there is also another group of works that show Gaudí's vision of the modern city, which offer an insight into his concept of the modern urban space.

In 1879, a year after graduating, Gaudí received a commission for a public work from the City Council. He had to design a series of ornamental gas street lights. Two models were produced.

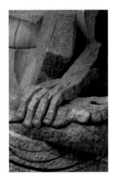

Temple of Sagrada Familia

Sculpture detail.

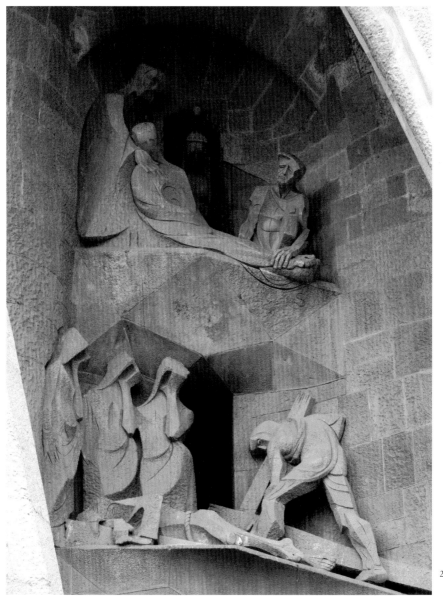

223

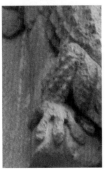

The most elaborate was one supporting six lamps for the square in the centre of Barcelona's Gothic quarter the *Plaça Reial*. A design by Gaudí for these street lights depicts them seen from below and presents them as a dramatic architectural addition to the streets and squares of the city. Rising from a marble base the iron column of the street light is decorated with the shield of Barcelona and at its top is the winged helmet and caduceus of the god Hermes. As well as being a messenger of the gods he is also the god of commerce, a very appropriate reference for Barcelona in this period. The simpler design of three lamps lacks the classical reference.

Temple of Sagrada Familia

Nativity façade, animal detail, Chameleon in the cloister

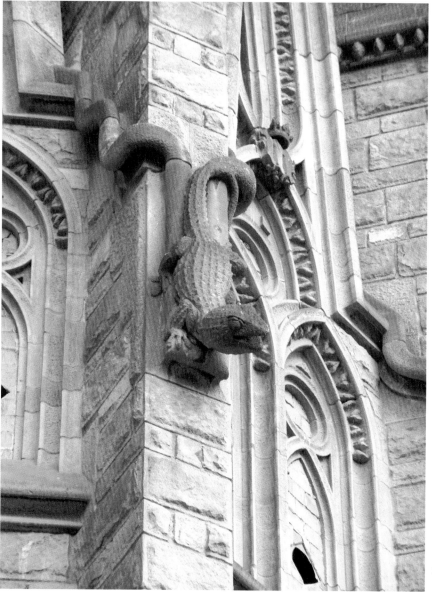

In 1880 Gaudí was involved in a second project to modernise the city with the addition of street lighting but this time it was to be electric. The lights were intended for a coastal promenade of Barcelona, and were unfortunately never built. Two designs exist which show Gaudí thinking on a far grander scale than two years earlier. The most finished drawing shows a figure standing by a lamppost that was intended to be nearly twenty metres high. It looks dramatically different to the previous designs. At the base there is an ornamental garden, which would no doubt have set the tone of colour for the work which the drawing suggests would have been painted.

Temple of Sagrada Familia

Details of architectural decoration forms

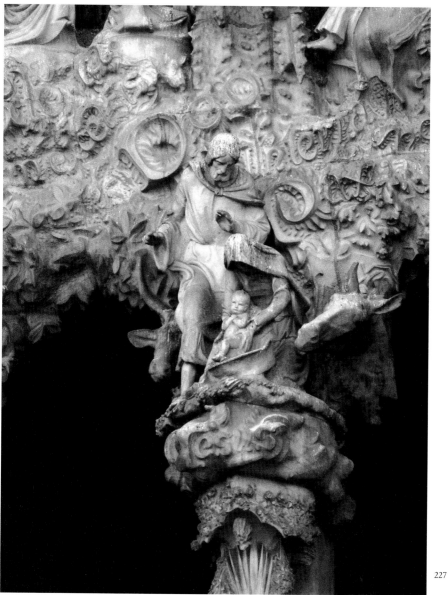

In addition it was adorned with metal shields of Catalonia and the names of famous Catalan admirals. History and politics are at the heart of these displays of modern technology. The electric lights seem to hang around a second raised ornamental flowerbed and the cords bearing the heraldry seem to be of secondary importance to the declaration of Barcelona's maritime history. Almost thirty years later Gaudí would return to this specific element of the modern city outside Barcelona in the small town of Vic. He had gone there to recuperate from an illness, and while there had become involved in plans to create a monument to commemorate one of Vic's famous citizens, Jaime Balmes Urpía.

Temple of Sagrada Familia

Detail of the Nativity façade, crowning of the Virgin

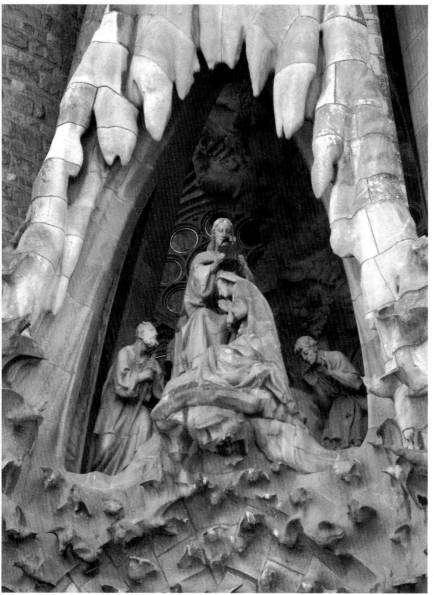

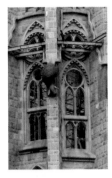

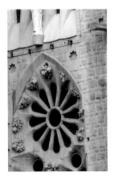

The project Gaudí recommended of some commemorative lampposts indicates how he sought to combine the modern with the past. Gaudí designed them and they offer a clear indication of his creative development as an architect. The finished works were installed in 1910. They are hard to analyse in detail as they were demolished in 1924. From archive photographs it is clear that Gaudí had clearly moved away from the classical vocabulary of the earlier lampposts to a more elaborate and decorative design. The basalt base offers a naturalistic foundation from which rises what is more arboreal than architectural. The supports for the lamps seem more like the boughs of a tree, with the lamps themselves like large fruits.

Temple of Sagrada Familia

Nativity eastern façade, view of stairwells in the towers

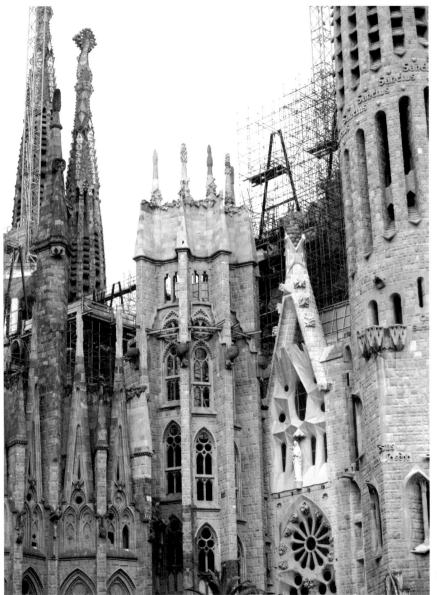

At the top there is cross that again evokes the substance of a plant. The second group of works that illustrate Gaudí's modernity is his work in the field of commerce. Of the group of small works that he undertook having just graduated one of the most important was, curiously enough, a display case for a glove-maker. The case was built so that Raimundo Comella could show his wares at the Universal Exhibition in Paris in 1878. Such exhibitions were an important feature of nineteenth-century life. The Great Exhibition in Crystal Palace in 1851 set a precedent for this type of event, which sought to display all the latest advances industrial society could offer as well as the work of those craftsmen who continued working in traditional media.

Temple of Sagrada Familia

Nativity façade, palmtree below sculptures
of trumpeting angels

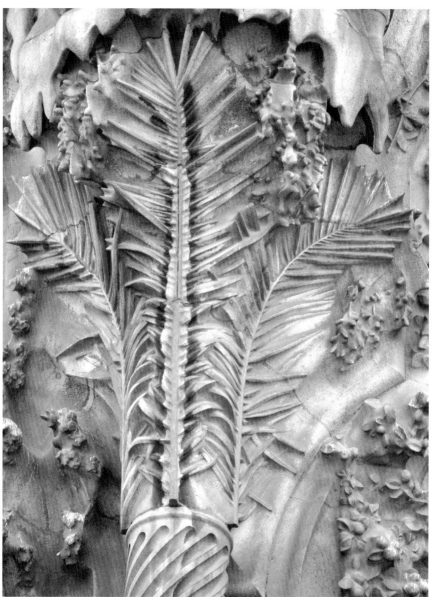

Unfortunately the display case no longer exists, although there is a drawing of a large glass structure. The best testament to its success is the fact that when Eusebio Güell saw it in Paris he was so impressed that on his return to Barcelona he sought out Gaudí and thus began the beginning of a long relationship of patron and architect which resulted in many of Gaudí's greatest works. Barcelona itself held a Universal Exhibition in 1888. Gaudí designed a Pavilion for the Transatlantic Company, owned by the Marquis de Comillas. Unfortunately little is know of his involvement as the exhibition was temporary and the designs no longer exist.

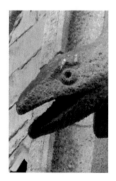

Temple of Sagrada Familia

Nativity façade, animal detail,
Serpent in the cloister

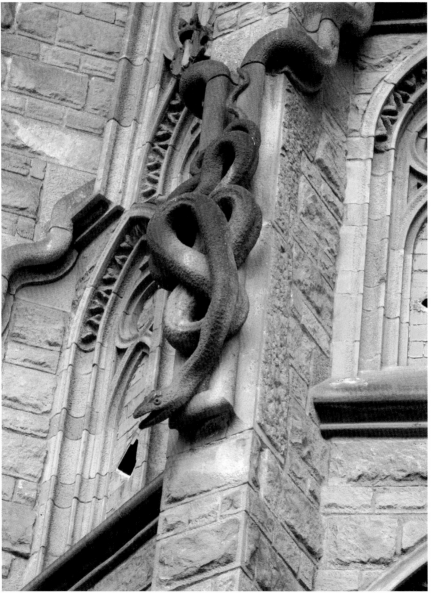

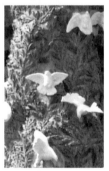

However, in 1910 Gaudí exhibited again at the Universal Exhibition held for a second time in Paris. On this occasion the display was Gaudí's own work, and in particular his work on the Sagrada Familia. Eusebio Güell covered all the costs for the display expressing his conviction in Gaudí's ability. There was a varied critical response to the work and its overtly religious theme.

While these exhibitions reveal Gaudí's participation in the cultural arena of his times there is little evidence that remains of the exhibitions themselves. Again, the passage of time has not preserved another unique group of works in Gaudí's oeuvre, which is his design for shops.

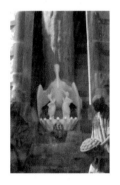

Temple of Sagrada Familia

Detail of the Nativity façade with cypress tree, the symbol of eternity

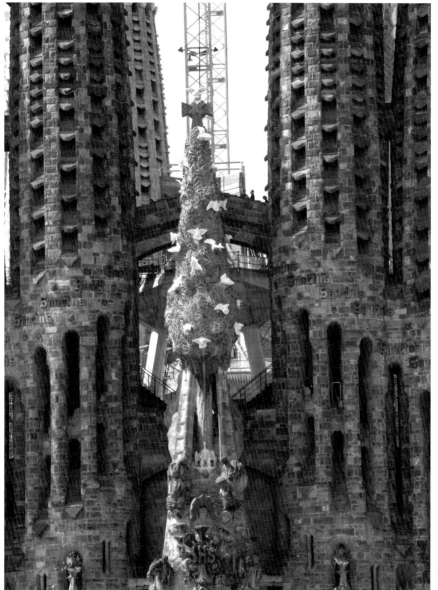

Although only drawings and photographic evidence remain they illustrate a popular and secular aspect to Gaudí's public commissions. In 1878 he designed a kiosk for Manuel Carré and Enrique Girossi. It was never built but planned as a large wrought-iron and glass structure intended for the sale of flowers. The glass would have been ideal for the flowers. In addition, the roof was extended out from the walls and so provided shelter for the plants from the strong Mediterranean sun. It also included a clock and gas lights. It appears Gaudí sought to create a structure that would make both its wares visible as well as be eye-catching with a number of details.

Temple of Sagrada Familia

New towers of the Nativity façade

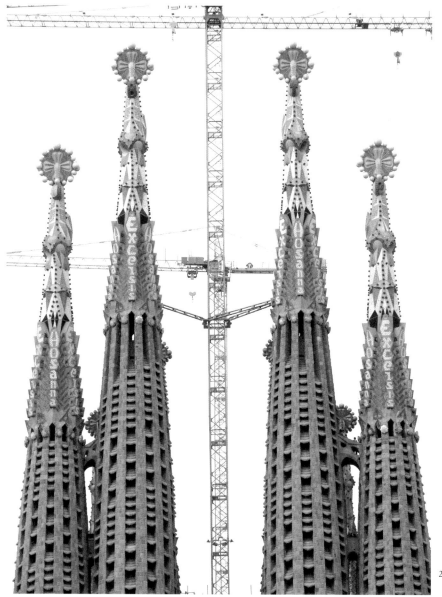

A second smaller commission that Gaudí undertook was to create the sign and façade for the Gibert Pharmacy. Little is known about the project, but a photograph records Gaudí's work. The script of the sign may be contrasted to the business card Gaudí designed for himself and is another example of his calligraphic design. The carvings are also characteristic of the decoration of his early furniture. Twenty-two years later Gaudí returned to the task of designing a commercial establishment, however this time as collaborator. The plan was much grander. An Italian businessman Falminio Mezzalana commissioned Gaudí to design a café on the corner of two of the principal streets of the *Eixample*,

Temple of Sagrada Familia

Detail of the Passion façade, sculpture of portal of Hope

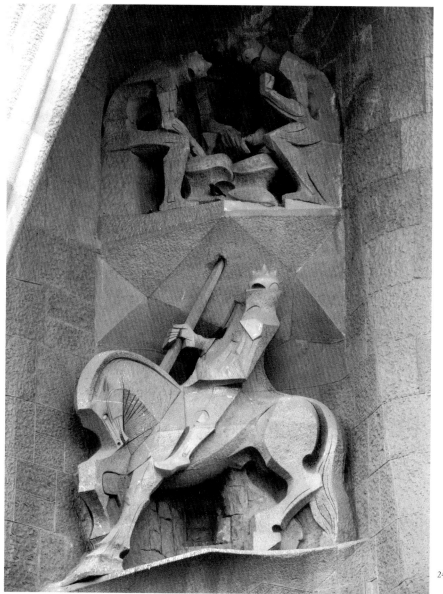

241

the *Passeig de Gracia* and *Gran Vía*. The finished work was called the Café Torino, and it was set up as a showcase for the vermouth Martini and Rossi. Although Gaudí never touched alcohol and was a strict vegetarian it did not prevent him from contributing to what must be a masterpiece in the bar designs of the period. The façade designed by José Puig i Cadafalch is a large kidney shape, supported by a wide central pillar with glass doors either side. In the only remaining photograph the scale of the window is striking and the graceful curve that surrounds it creates an effect of an elegant urban cave. On the pillar there is a *modernista* sculpture of a nymph-like figure with a brimming cup by Eusebi Arnau.

Temple of Sagrada Familia

Sculptures of trumpeting angels

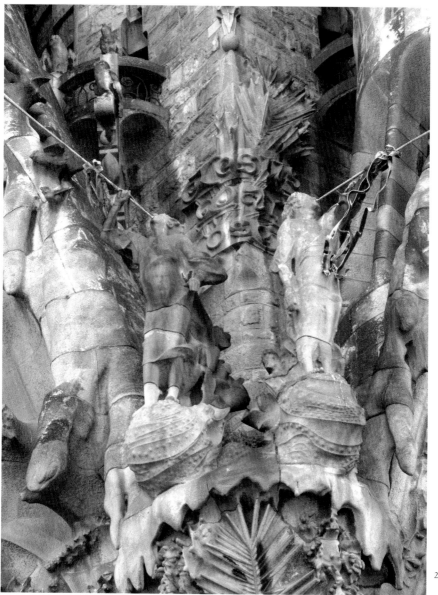

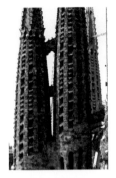

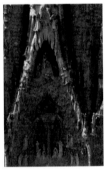

Above her is a flourishing vine branch. Inside the bar, which is where Gaudí's skills were deployed, was a series of rooms decorated by Venetian and Catalan artists. Gaudí designed an orientalist salon in the Moorish style. As he had previously done in the *Casa Vicens*, Gaudí used compressed cardboard to create the exotic effects on the walls and ceilings. The final work to be discussed was again never built by Gaudí, and in many ways it deals primarily with the recognition of Gaudí in the United States. In 1908 two American visitors expressed considerable interest in Gaudí's work and suggested that Gaudí design a large building in New York.

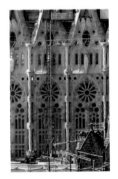

Temple of Sagrada Familia

View of the old façade

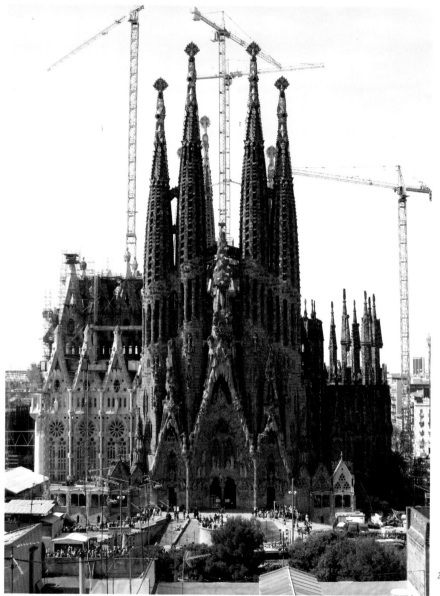

It was a cluster of buildings designed with three aims: residential apartments, restaurants, and spaces for exhibitions and other cultural and recreational activities. The most finished drawing we have of the building is by Gaudí's assistant Juan Matamala, whose short article on this episode of Gaudí's life provides most of the information we have. Matamala's design provides a fascinating insight into how Gaudí might have addressed that most modern of architectural forms, the skyscraper. Had he undertaken this commission the modern image of Gaudí would undoubtedly be very different, but illness and the many commissions he had underway in Barcelona meant that it was not possible.

Temple of Sagrada Familia

Detail of the old façade

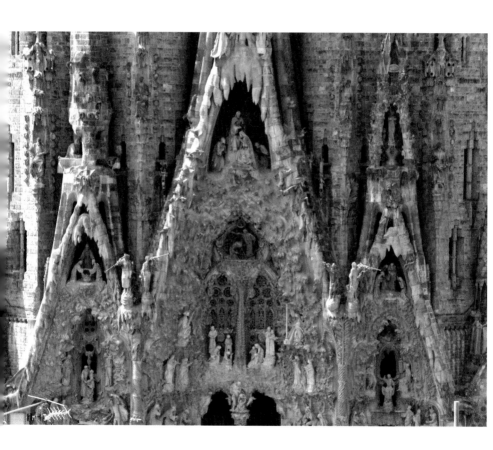

Index

E

T